D1252643

MAX BECKMANN

HANS BELTING

MAX BECKMANN

TRADITION AS A PROBLEM IN MODERN ART

WITH A PREFACE BY
PETER SELZ

TRANSLATED BY
PETER WORTSMAN

TIMKEN PUBLISHERS, INC.
NEW YORK
1989

Preface and translation copyright © 1989 by
Timken Publishers, Inc.

© for the reproduced works of Max Beckmann and
his writings by Peter Beckmann, Murnau.

Published by Timken Publishers, Inc.
225 Lafayette Street, New York, N.Y. 10012

Originally published as *Max Beckmann: Tradition
als Problem in der Kunst der Moderne*
Copyright © 1984, Deutscher Kunstverlag, Munich

ISNB 0-943221-06-4

Library of Congress Cataloging-in-Publication Data

Belting, Hans.
 [Max Beckmann. English]
 Max Beckmann: tradition as a problem in
 modern art / Hans Belting; translated by Peter
 Wortsman: with a preface by Peter Selz.
 p. cm.
 Translation of: Max Beckmann: Tradition als
 Problem in der Kunst der Moderne.
 Includes bibliographical references.
 ISBN 0-943221-06-4: $29.95
 1. Beckmann, Max, 1884–1950—criticism
 and interpretation.
 I. Title.
 ND588.B37B4513 1989
 759.3—dc20 89-20211
 CIP

Printed in the United States of America
Set in Bodoni Book
Typesetting by EyeType, New York
Production by Stevan Baron
Design by Wendy Byrne
Copy editing by Anna Jardine

CONTENTS

PREFACE BY
PETER SELZ

Inevitably, we see the past through our current vision. It is no surprise, therefore, that the so-called New Expressionists in Germany, Italy, and the United States have pointed to Max Beckmann as a paradigmatic figure, an artist who adhered to the figurative mode of expression, which he endowed with narrative and often mythical imagery. The centennial of his birth, 1984, was a time of homages to and retrospective exhibitions of Germany's greatest modern artist, in both the Federal and the Democratic Republics of Germany as well as throughout Europe and the United States. But locating Beckmann a posteriori as a "precursor" of "refigured painting," as the father figure of a movement that is often more ponderous than substantial, is to bury him by misplaced praise.

Unlike many of his boisterous heirs apparent, Beckmann in his painting explored the dichotomy between *bios* and *logos*, sensing that the artist's task was, above all, to penetrate *bios*, or matter, in order to gain access to *logos*, the spirit, to find a bridge from the here and now to the invisible. Like his contemporary Martin Heidegger, Beckmann was acutely aware of man's alienation in the world and the fragmentation of modern life. A disciple of Nietzsche since his early youth, Beckmann turned to remythification in his late masterpieces, whose metaphysical code is not subject to verbal explication but is able to evoke a sense of understanding on the purely visual level. For this purpose he used every means at his disposal—not only space and color, line and shape, but also the active human figure and a diversity of meaningful objects.

In 1948, two years before his death, in one of his "Letters to a Woman Painter," he warned the artist not to "forget that the appearance of things in space is the gift of God, and if this is disregarded in composing new forms, then there is the danger of your work's being

damned by weakness or foolishness, or at its best it will result in mere ostentation or virtuosity" (see p.124). From his beginnings as an artist until the end of his outstanding career, Beckmann repudiated the idea of art as decoration or *belle peinture*, and formalism of any kind. For him art was a means of comprehension and enlightenment, of coming to terms with existence—man's, and his own.

Like Picasso, with whose art Max Beckmann maintained a lifelong silent polemic, Beckmann went through a number of distinct but connected "periods" in his painting. In the early years of the century the young painter achieved success and high praise as a romantic realist for his large and ambitious canvases, extending the tradition of Géricault and Delacroix. The carnage of World War I disillusioned the man and transfigured the artist. In 1919 he told Reinhard Piper, the publisher of his prints: "In my paintings I accuse God of his errors. . . . My religion is hubris against God, defiance of God and anger that he created us that we cannot love one another." In the chaos of the postwar years, he created powerful works recording and denouncing the social and political situation of his time. During this period of disillusionment, critics associated the artist with the sober chroniclers of the New Objectivity (Neue Sachlichkeit), but Beckmann, always the maverick and loner, chose never to be part of any group, movement, or style. He spoke of Expressionism as unstructured emotion and distanced himself from any "-ism," warning against the collectivism of the modern era.

Beckmann felt that he belonged to the great European tradition. Indeed, the motifs of his paintings in the late 1920s and early 1930s were in the tradition of Western art. But he transformed the landscapes and still lifes, the portraits and nudes into a thoroughly modern idiom. Once more he achieved international recognition as an acknowledged master of his time. But with the impending disaster in Europe his paintings became more visionary and filled with personal and disquieting symbolism. As the Nazis assumed power, Beckmann became a chief target of vilification. Nearly six hundred of his works were confiscated from German museums, and when his paintings were displayed in the infamous exhibition of "degenerate art," he left Berlin for Amsterdam, never to return to his native land.

Beckmann was one of the rare twentieth-century artists whose creative energy did not decline in later years. Quite the contrary, he produced a third of his life's work during his last ten years, the period of exile in Amsterdam, St. Louis, and New York.

The terrain for Beckmann's reputation in this country had been prepared since the 1920s, when J. B. Neumann, that knowledgeable dealer and enthusiastic connoisseur, introduced modern German art

to the American public. This effort was an uphill battle, because in the American mind, modernist art had been almost synonymous with modern French art ever since the predominance of French painting in the Armory Show of 1913. Alfred H. Barr, the founding director of The Museum of Modern Art, brought a more pluralistic view to bear on the understanding of the art of this century and mounted an important exhibition, "German Painting and Sculpture," in 1931. It included sixty of Beckmann's works. James Johnson Sweeney, working as an art critic at the time, reviewed the exhibition and recognized Beckmann as belonging "without question in the first rank of contemporary painters." The Museum of Modern Art acquired Beckmann's first triptych, *Departure*, in 1942 and placed it on permanent view, together with Picasso's *Guernica*, as one of the great masterpieces of our time. In 1948 Perry Rathbone, director of the City Art Museum of St. Louis, organized a major retrospective of the artist that traveled to Los Angeles, Detroit, Baltimore, and Minneapolis and created significant critical acclaim, followed by acquisition of his work by American museums and private collectors. Beckmann himself accepted an invitation to teach at Washington University in St. Louis, filling the post vacated by Philip Guston, a great admirer of the German painter's work who had gone to the American Academy in Rome. Beckmann journeyed to many parts of the United States and taught summer sessions at the University of Colorado and at Mills College in Oakland, California. In 1949 he moved to New York to teach at the Brooklyn Museum School, where he remained until his death in December 1950.

The 1950s was the decade of the undisputed triumph of American painting, and the abstract painting of the New York School enjoyed a hegemonic position. It was only in 1964, when this writer organized a large retrospective of Beckmann's work at The Museum of Modern Art (a show that also traveled to Boston and Chicago), that renewed attention was given to Beckmann's art in this country. There is little question that his painting as well as his actual presence here during a critical period had a vital impact on the return to figuration in American art. Abstract art, it seemed, was not the culmination of art history. The search for human identity through art continues.

Nobody in modern art was more actively engaged in this quest than Max Beckmann. In his oracular late canvases—especially in his polyharmonious triptychs—he drew on art, mythology, literature, history, and contemporary events to approach the human condition with the veiled language of his art. His figures were the performers enacting the human drama and he was the circus barker and director as well as the protagonist of the pageant.

By endowing vision and dream with precise structure and meticulous detail, Beckmann, the traditionalist, belongs to that mainstream of modernism which has its parallels in the writings of Thomas Mann, James Joyce, and Franz Kafka, in the paintings of de Chirico, Picasso, and Bacon, in the films of Bergman and Antonioni. In all their work the sense of human estrangement is enhanced by the use of hard physical reality. In the current volume Hans Belting explores the dialectic between tradition and modernism in Beckmann's art and adds significantly to the understanding of a great European painter of our time.

Peter Selz
Berkeley, California
May 1989

1 A GERMAN BIOGRAPHY AND ITS ECHO

A great deal of cultural activity erupted on February 12, 1984, the occasion of Max Beckmann's hundredth birthday. The high point was the major exhibition that began in Munich and traveled to Berlin, St. Louis, and Los Angeles.[1] Writings about Beckmann, however, are still strikingly small in number. The posthumous applause rings false. Was Beckmann rightfully considered "Germany's greatest living artist," as *The New York Times* wrote of him in 1946? He became a member of the Bavarian Academy of Fine Arts, but only in the last year of his life. At the time, Wilhelm Hausenstein, a Beckmann scholar, was its first president. He had not, however, seen Beckmann since 1928, when, in a catalogue printed to accompany the Beckmann exhibition at the Galerie Franke, he saluted the emergence of the artist's classical period. Hausenstein had also participated in 1924 in the Beckmann almanach put out by Piper Verlag in Munich. Both the catalogue and the monograph were critical to the establishment of Beckmann's reputation. Hausenstein wrote at the time: "If I should now attempt to conceive of a specifically German art, its name would be Beckmann."[2]

Unfortunately, as we know, the Nazis thought differently. In 1937, in the very same Haus der Kunst in which the artist's work was exhibited in 1984, his paintings were prominently represented at the defamatory exhibition "Degenerate Art." Outside Germany, on the other hand, he was perceived as so German that in the expiatory exhibition presented in London in 1938, not a single painting of his was sold. It was the Americans who rediscovered him. That is why so many of his major works hang in American museums and collections today. It is clear that Beckmann the painter was inseparable from his German identity. However, as German painting did not claim a central position in the pantheon of modern art, this also had a detrimental effect on the art world's appraisal of his work.

I would like to attempt in this first part of my sketch to bring together Beckmann's biography with his reception in art historical circles and related literature. He ranks with the most important of the modern artists, although this is not to say that he has thereby eluded the barbs of controversy. This distinguishes him, for instance, from Manet and Cézanne, and also from Picasso. Critics do not know exactly where to place him in the history of the artistic avant-garde. He himself wanted no part in their antitraditional program—a fact that earns him the admiration of certain circles today.

It is important to remember that Beckmann's path as an artist began in nineteenth-century Germany, in the provinces, far from the artistic hubbub of Berlin. He was born in Leipzig in 1884. By the time of his graduation from art school in Weimar in 1902, he was saluted by Edvard Munch.[3] Early recognition placed him in the circle of the Idealists, such as Hans von Marées, and the Symbolists. In 1905 Beckmann moved to Berlin. His training put him at first so far from contemporary artistic trends that a trip to Paris bore no result. A short visit to the Villa Romana in Florence, on the other hand, proved more fruitful. Here Beckmann studied the work of the old masters. Major themes and large formats announced aspirations that were not, however, appropriate at the time.[4] In 1913 the first monograph on Beckmann appeared, a book by Hans Kaiser about the not yet thirty-year-old artist. Still Beckmann found no access to avant-garde circles like Die Brücke.

Then came World War I, at a time when the artist had not yet established deep roots. In 1915 the war transplanted him to Frankfurt, and the troubled painter sought access to modern art, as stereotypes of prewar traditions crumbled around him. His vision of redemption, *Resurrection* (1909),[5] whose Nietzsche/Wagner–inspired sentiments were painted in neat opposition to the Protestant pastor's household of his mother-in-law, was taken up again in a monumental painting showing a bombed scene of crippled victims of war. But the subject of this second version of *Resurrection* could no longer be mastered, and the unfinished canvas was kept in Beckmann's Frankfurt studio as a monument to an artist's defeat.[6] The refined Berlin arbiter of taste Julius Meier-Gräfe viewed the "shrieking question marks" in Beckmann's oeuvre as the "signs of madness of an entire generation."[7] Others saw his vision of hell—a series of prints to which the painter turned his energy—as the one accurate portrayal of the times.[8] The hallmark of Beckmann's painting was a cold precision that allowed him to master not only his style but also the artistic uncertainty of the moment.[9] His tendency toward the metaphysical nevertheless could

not be suppressed. It led him to understand painting as a tool of salvation—and as an escape from the nihilism of the day.

Beckmann now made a second trip to Paris. Though he still suffered from artistic "bellyache," as he wrote in 1925 to his dealer, J. B. Neumann, he nevertheless concluded that "Paris no longer presented any competition to his talents."[10] A telling error in judgment. Yet the word "competition" ought to be kept in mind.

The 1920s were the best and most productive years of Beckmann's artistic reception. The sharp critiques published by Paul Westheim (1923) and Carl Einstein (1931), neither of whom belonged to the Beckmann camp, are striking and prophetic analyses of his path as an artist.[11] Writers of a literary bent like Wilhelm Hausenstein and Benno Reifenberg published their own interpretations of his work and took a stand in his favor. It was the only period in which Beckmann's art enjoyed the attention of a rich critical chorus of contrapuntal opinion. "New Verism" (Neue Sachlichkeit) and "Magical Realism" were labels attached to him, once "Expressionism" fell out of vogue. In 1925 Günther F. Hartlaub divided the art world into Verists and Classicists.[12] But these categories no longer applied to Beckmann. In 1928 Wilhelm Hausenstein launched the legend of the solitary *Einspänner*, the one-horse carriage, which alone carries "the heavy burden" of art history on its weary shoulders.[13] The following year, Julius Meier-Gräfe saluted the quality of the *peinture* in *Gypsy Woman* (fig. 12) remarking: "The inconceivable has happened. We once again have a master in our midst," a master of the big themes of figural painting, who measured up to the challenge of the French and the model of tradition[14]—an appraisal with which Beckmann himself was no doubt well pleased, as it was just what he set out to achieve. Here, according to Hausenstein, was the beginning of "what will one day be called his classical period."[15]

In the 1930s the gush of Beckmann literature dried up. One reason was that Beckmann abandoned his classical style, and by his flight into myth he likewise disappointed the followers of his early realism. But the main reason for his sudden decline in favor was, of course, that after 1933 no one was allowed to write about him. His dismissal as professor at the Städel School in Frankfurt came in 1933, followed by his move to Berlin and finally, in 1937, by his emigration, in the wake of the wind shift in Munich: "degenerate art" was replaced by the new so-called art of healthy perception. Beckmann left Germany on July 19, 1937, the day before the "Degenerate Art" exhibition was to open in Munich. From 1937 to 1947 he lived as an émigré in Amsterdam. He was never to return to Germany. The lacuna in the Beckmann

literature of this period became a serious handicap for later Beckmann scholarship. His change of style, his mythological themes, his relation to the Surrealists—all these aspects were no longer written about. And they are still not being written about. Only the philosophical paintings that Beckmann began in the early thirties are discussed, but they are merely deciphered as though they were nothing more than painted crossword puzzles.

Beckmann himself had departed from the scene and left behind Beckmann criticism. His best interpreter in those years was still the young author Siegmund Morgenroth, who wrote in Paris under the pseudonym Stephan Lackner. In 1933, at age twenty, Morgenroth had "exhumed" and acquired Beckmann's painting *Man and Woman* (fig. 10) from the basement of the art museum in Erfurt, where it could no longer be displayed. In 1938 he urged the painter to participate in the London exhibition, and since no one else wrote about him anymore, he encouraged Beckmann to write on his own behalf about his theory of art (see p. 117). Morgenroth himself composed an essay at the time, "The World Theater of the Painter Beckmann," a text that became the bible of Beckmann studies. Beckmann cabled his approval of the young writer's interpretation.[16]

At the same time, a new wave of enthusiasm for Beckmann erupted in New York. The young painters of the New York avant-garde, later to become the masters of the New York School of abstract painting, stood in awe before two paintings that made their way there in exile: Picasso's *Guernica* and Beckmann's triptych *Departure* (fig. 27). Both ended up in The Museum of Modern Art, *Guernica* albeit only on extended loan until it could be returned to Spain.[17] Beckmann's painting, as different as it was from Picasso's, likewise inspired the sudden emergence of myth in art, a trend that Adolph Gottlieb and Mark Rothko later developed with abstract signs and hieroglyphs.[18] The art historians Alfred H. Barr and James Thrall Soby promoted Beckmann in the United States. In 1947 Beckmann himself arrived in America. During the few years remaining until his death, he must have felt a curious mixture of recognition and alienation, for both literally and figuratively the fans did not speak his language. In December 1950, the German artist in exile fell dead on a stroll through New York's Central Park—a form of death which appears, ironically, to have fulfilled Beckmann's sense of self as a stranger on a foreign stage.

Shortly before his death, the climate changed again in Germany. The time was ripe for rediscovery. In 1946 Günther Franke arranged

the first major postwar exhibition at the Stuckvilla in Munich. Old friends once again emerged in print and attempted to understand the new Beckmann. In 1949 Benno Reifenberg and Wilhelm Hausenstein even coauthored a book about him that managed to reach the painter in his lifetime.[19] Shortly after Beckmann's death, the Beckmann Society was established in Munich. But these memorial tributes ran contrary to a new artistic trend of abstract art in which Beckmann had no place. And every form of realism, given that Germany had not overcome its recent past, was rendered taboo. This explains perhaps the retreat of Beckmann studies into the debate over the content of his paintings. Iconographers pressing Beckmann into the mold of a premodern symbolist and missionary, who by his art legitimized the contemporary trend toward an engaged figural art, now spoke up. Beckmann's artistic reception by the painters of the German Democratic Republic could well be the subject of a whole other study: the 1983 exhibition "Zeitvergleich" swept the new Beckmannians in East Germany into the limelight.[20] The German, all too German painter still stands, however, in the shadow of the history of his reception, a history in which the true contours of his art tend to be blurred. Esoteric paintings have been discussed as if Beckmann had been concerned about nothing but dark meanings. The two-volume catalogue of Beckmann's paintings by Erhard and Barbara Göpel published in 1976 lists seventy-one bibliographic references to the mysterious painting *Departure*, while other works, such as *Woman Meditating by the Sea*, merit only a few references.[21]

Even Beckmann's own texts raise more questions than they answer. It has now become established custom to use them as if they alone could explain the man and the artist. The truth is, though, that they often fail even to explain themselves. They require their own interpretation before they can be applied in turn to interpret Beckmann's paintings. And their historical context must also be taken into account. The texts composed after World War I were conceived in an altogether different climate from those curiously programmatic theses such as "The Artist in the State," published in 1927, and "Six Sentences on the Structure of Painting," published the following year. In 1938 an altogether different Beckmann, the emigrant painter in London, expounded "On My Painting." Finally, "Letters to a Woman Painter," composed in 1948 in the United States, conveys a wisdom about life and a personal concept of art that derive from an altogether different milieu. The diaries from the last decade of his life (1940–1950),

which, aside from very early entries, are all that remain of his private notations, mirror the changes in Beckmann's reaction to the conditions of his life as much as they attest to a virtually constant sense of self.[22]

Beckmann, as we said before, has long been accorded the status of a great painter. Even contemporary writers like Peter Härtling have on the occasion of the Beckmann centenary confirmed in print their enthusiasm for Beckmann as an established master.[23] I must, however, add that Beckmann does not share these lofty heights with similar fellow artists. Antipodes like Paul Klee, who as a painter has nothing in common with Beckmann, are accorded master status at his side. Even cool-headed critics today construct a personal art history based on aesthetic views. Behind the scenes the struggle between realism and abstraction continues.

Three positions crop up again and again in the current Beckmann dialogue. First, there are the old Beckmannians, old followers and sentimental adherents. Then come the dogmatists of the avant-garde, in whose picture of history Beckmann fits all the less, the more they identify themselves with its radical tenets. And finally there are the Post-Moderns, the Neue Wilden and Young Mystics and above all the mythophiles who feed on Beckmann: even filmmakers like Andrei Tarkovsky (*Nostalghia*) slip into a neomysticism that can easily lay claim to Beckmann. There are, of course, other responses. Most of us carry in ourselves an idea of art and art history in which Beckmann either does or does not fit. For my part, I can make use only of views that, proceeding from a historical perspective, seek to establish Beckmann's place in the history of modern art.

2 IN THE MIRROR OF ART HISTORY

Beckmann's self-image as an artist is best illustrated by a photograph of the painter taken when he was not yet thirty years old. It shows him in 1912 in his studio in Berlin-Hermsdorf. *The Sinking of the Titanic* (fig. 1), the giant canvas painted in that same year, is propped up against an easel.[1] It is a modern subject but looks like a historical tableau of the Romantic period. The format alone evinces the self-conscious grandeur of a masterpiece, in the manner of works by Delacroix or Géricault. The depiction of the *Titanic* tragedy as a modern *Eroica* reminds one of Manet's visions of old sea battles, such as *Rochefort's Escape by Boat* (1880).[2] Critics roundly misconstrued the young painter at the time, scornfully dubbing him "a journalist and illustrator."[3] A depiction of the ocean-liner catastrophe in the icy waters was intended to portray a human fable in contemporary guise, the tragic life-and-death struggle, and the stubborn self-assertion of man. It is another version of *The Flood* (1908) and as a subject just as monumentally conceived.[4]

In the photograph, seated before this painting, Beckmann assumes the self-glorifying studio pose of the artist who interprets the world and thereby asserts his dominion over it, with his hands buried in his pockets, legs crossed, and his gaze fixed confidently on the viewer. To the left and right, respectively, a nude study for the painting *Resurrection* (1908) and *Large Death Scene* (1906) lean in the photo like the wings of a triptych. They apostrophize the struggle with death on one side and resurrection on the other but also represent the requisite genres, such as nude, historical tableau, and symbolist interior, in the manner of Edvard Munch, who had praised the young painter for his *Large Death Scene*. Even the small landscape to the rear represents a genre essential to the repertoire of a master.

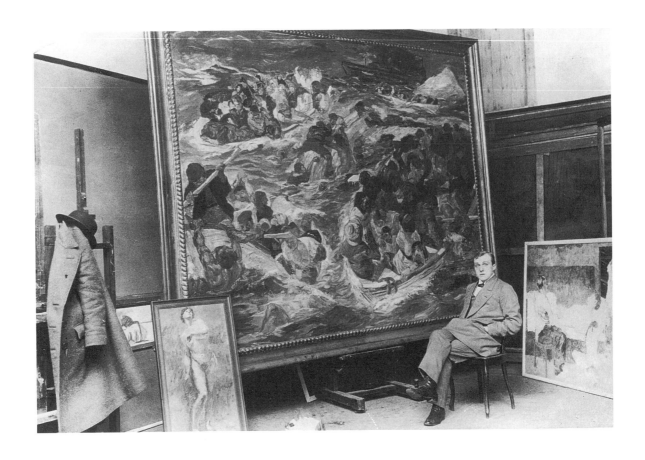

From the retrospective view of 1924, Julius Meier-Gräfe ridiculed the young, prewar Beckmann who had monumentalized his terror and replaced depth with size.[5] But for Beckmann, the desire to present art as a metaphor for life became a lifelong pursuit. In 1912, the same year the photograph was taken, Beckmann pitted himself against Franz Marc in the periodical *Pan*, writing: "The laws of art are eternal and unchanging, just like the laws of morality in us."[6] Beckmann also had a view of Cézanne different from that of the avant-garde, recognizing him not as a revolutionary of artistic form but rather as a modern painter of eternal human values. Seriousness is one of these espoused values. Art should not be mere decoration, should serve not to entertain but to enlighten; indeed, it should offer the viewer a glimpse of redemption. In later years Beckmann went so far as to think that by compelling his art on people he could effect their betterment. Such a serious sense of purpose allowed for neither the spectacular antics nor the experiments of his fellow painters from the Expressionist movement. To play with new forms still seemed all too frivolous a pursuit at the time.

But the pathos of Lovis Corinth's and Max Liebermann's Impressionism had run its course, and the bourgeois context, which Beckmann could not escape, was not serious enough to satisfy his youthful German *Sturm und Drang* temperament. The only artistic alternative that remained, therefore, was to look back to the old masters. Their art was of a greatness and magnitude that Beckmann longed for and missed among his contemporaries. It was this tradition (from which one of Beckmann's opposites, Marcel Duchamp, conclusively cut himself loose at the same time) that Beckmann wanted to save in modern art. The problem for a painter like Beckmann was the pressure of the modernist creed, something he had both to acknowledge and to counteract if he did not want to sink into obscurity. To look back at the example of the old masters was a utopian vision for him, a means of escape from the inadequacies of modern art. Also, Berlin was not Paris, and the German capital lacked even the artistic "schools" with which one could engage in serious polemic. Only the spokesmen of the Blaue Reiter did he consider worth engaging in controversy whenever they seemed to betray the basic qualities of what Beckmann considered art.[7]

All Beckmann's self-portraits manifest the same seriousness with which he first appeared on the scene, and the same defiance, justified by his resistance to his situation. They do not allow for anecdotes. Nor is this the kind of autonomous painting that merely mirrors itself. Art could be great, in Beckmann's eyes, only if it encompassed the world. The world had first, of course, to be interpreted and transformed into art. For true reality is that of the painting, "the only true reality there is," as the painter wrote in 1939 to J. B. Neumann.[8] In art there is the possibility of advancing to a true state of being. Here, in essence, is the contradiction inherent in the "artistic metaphysics" of Nietzsche and Wagner, a philosophical strain still virulent in Beckmann's thinking—a stance that placed him in an extreme tradition of German idealism.[9] Art was supposed to testify to life but also to stand above it, indeed to become so powerful that life would finally have to follow its dictates. Proclivity to the total work of art is a portentous answer to the problem.[10] Disillusioned idealists like the poet Gottfried Benn sought in "style" a stand against the alienation they experienced.[11]

Beckmann himself never escaped the contradiction between a search for his place in the world, which as an individual he continued to crave, and an equally powerful need for withdrawal from the world, the prerequisite state for the self-expression of art. He did not want to be a realist, for there was too little art in realism. But neither did

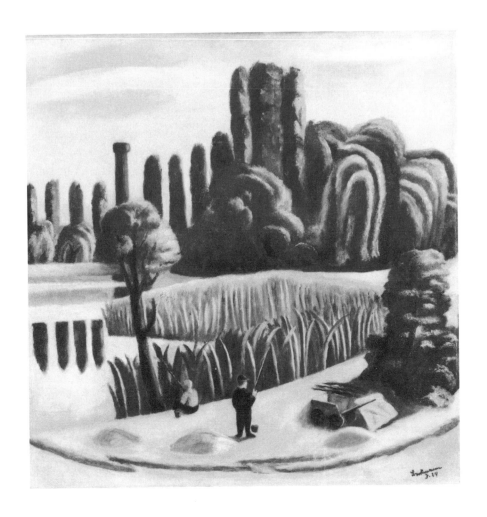

the absolute art espoused by abstract painters of the day appeal to
him: it contained too little reality. In the third edition of his *Die Kunst
des 20. Jahrhunderts*, published in 1931, the art critic Carl Einstein
called Beckmann's attempt at a synthesis of modern consciousness and
the inheritance of old forms a tragic problem. "No contemporary artist,"
wrote Einstein, "is so tragically embroiled in the question as Beck-
mann, who wavers between ironic toughness and old inherited form."[12]

Cézanne is really the last old master—or more precisely, he has
become the first "new master," Beckmann wrote in 1948 in "Letters to
a Woman Painter," and with these words he essentially revealed his
own self-image.[13] He likewise aspired to an equal standing beside
Piero della Francesca, Uccello, Grünewald, Orcagna, Titian, El Greco,
Goya, and van Gogh. He found Bosch, Rembrandt, and Blake to be

3. BANKS OF THE OISE

*Henri Rousseau, 1908,
Northampton,
Massachusetts, Smith
College Museum of Art*

a rather congenial circle of friends, and his first teacher remained nature, through whose tutelage Cézanne, as he himself said, wished to realize the classical. Such a self-appraisal on Beckmann's part was not a false delusion of grandeur, but rather a consequential function of his resolve to carry on the great tradition of art.

Significant here is the somewhat strained image of an art historical evolution in which Beckmann wished to play a part. He mentions the naive painter Henri Rousseau, the Douanier, in "Letters to a Woman Painter": "Every form of significant art from Bellini to Henri Rousseau has ultimately been abstract."[14] By way of reconsidering the direction of his own landscape painting in the early twenties he makes reference to Rousseau, for example in *Landscape with Lake and Poplars* (1924; fig. 2).[15] The depiction of the Ostpark in Frankfurt was clearly inspired in its soft tones, its archaic forms, and its magical reflections in water by a painting such as Rousseau's *Oise Shore* (1908; fig. 3). At the same time Paul Westheim in his remarks on contemporary art praises Rousseau as the last painter for whom art and life still constituted a unity.[16] Rousseau's unmediated experience, which modern artists longed to retrieve, was rooted in an innocence of seeing. Thus he was able to conjure a figural world that had become alien to others. In

1925, in an important book on Post-Expressionism, for which Rousseau's *Sleeping Gypsy* served as the frontispiece, Franz Roh put the matter succinctly: "Cézanne was the founder of the modern dynamism leading to abstraction. Rousseau was the founder of the modern tendency toward a static, tangible reality."[17] In other words: Rousseau was the father of objective art, as Cézanne was the pioneer of abstraction. Fritz Wichert still saw matters this way in the catalogue text that accompanied the highly esteemed exhibition "From Depiction to Symbol," presented in 1931 at the Kunstverein in Frankfurt.

If Beckmann openly hearkens back to Cézanne and takes his cues from Rousseau, there is clearly a purpose in this, indeed an artistic program: he wants to inherit and integrate the entire tradition bequeathed by these two progenitors of modern art, whose disparate influences split off into an objective and an abstract direction. In the 1931 edition of his history of twentieth-century art, Carl Einstein summed it up: "Beckmann no doubt attempted to bring together something like an aggregate of modernism," and to try "not to elude the conflict between artistic preconception and empirical motif, but rather to escalate that conflict into an almost tragic confrontation." Moreover, Einstein concluded of Beckmann, "with the evocation of a dream he wards off the banality of his subject."[18] This is, of course, a common problem of representation in modern art. Consciousness separates the artist from the existence of the objects he depicts. Beckmann made it his life's work to find a resolution to this split. He on the one hand lay stubborn claim to a very personal art and on the other acceded to the strictures of a universal norm of art. Since such a lofty ideal of art was at stake, Beckmann, who around 1920 had won so much acclaim as a realist, could no longer insist upon illustrating his own society. He sought more than a mere critique of current conditions, and yet he shied away from any disconnected aesthetic canon of art. Avoiding both, he struggled for a new dignity of figurative art.

In Paris, another loner, Picasso, set the pace and likewise irritated followers who could not keep step. With his neoclassicism, he even turned his back on those whom he had led in the struggle for Cubism. His position in the hierarchy of the avant-garde was so unassailable that he could even allow himself heresies. His artistic vitality became a provocation to the all too serious German painter, who could only dream of such a sovereign place in the ranks of art history. Beckmann had Picasso in mind when he wrote to J. B. Neumann in 1926: "One must sometimes step over—not sidestep—those ahead of us on line. And Vollard is your only ancestor in the entire world."[19] It requires

but little stretch of the imagination to replace the name of the famous Paris art dealer with that of Picasso, and to interpret this imperative as a veiled call to arms for Beckmann himself. In 1930 the insistent message abounded in Beckmann's communications that one had "to declare war" on "that Rosenberg–Picasso crowd now rendering the art world sterile." Beckmann perceives the "clique" around Picasso's art dealer Rosenberg as the "enemy." One can combat the "mechanistic enslavement" of a machine aesthetic propagated in Paris, asserts Beckmann, only with a counterattack of sentiment and humanity.[20] But Picasso himself could not be reduced to such a simplistic image of the enemy. In 1923 Jean Cocteau's monograph had introduced the new Picasso of the twenties.[21] The publication was illustrated with works, many of which soon found their way into the collection of Gottlieb Friedrich Reber (1880–1959) in Lugano, as Oscar Schürer's 1927 text on Picasso confirms.[22] Reber was one of the most important German art collectors and Beckmann painted his portrait in 1929 (fig. 7). But besides this encounter with the recent oeuvre of Picasso, Beckmann had spent too much time in Paris to leave the shadow of the illustrious Spaniard.

In his work, Beckmann came closest to Picasso in two domains: the Cubist still life and the classicist figure painting. Beckmann's versions bore his own artistic stamp, yet one would be hard-pressed to deny the obvious influence. *Portrait of Minna Beckmann-Tube* (1924; fig. 4) bears direct comparison with Picasso's *Portrait of Olga* (1923),[23] the former work clearly competing with the elegant contours and surface lighting of the latter, echoing the tension between a perception of the model and the classical laws of painting that Picasso derived from Ingres's influence. Beckmann's interpretation of the woman in the painting is different from that of Picasso: the German painter depicts his wife as an introverted individual whom he does not fully understand. But the two depictions have a sensuality in common. While still at work on the piece, Beckmann wrote to Neumann that he wanted now to create a "painterly music . . . to paint a life that simply exists. Without thoughts or ideas. Replete with colors and forms that nature and I myself conceive. To paint it as beautifully as possible."[24] It reads almost like a vision of Picasso's. Yet the painting contradicts the plan. Such classicism remained an episodic presence in Beckmann's oeuvre, whereas the burden of tradition did last.

The portrait emerged triumphant in Beckmann's work during this period. He painted timeless tableaux whose figures appear larger than they in fact were. His cold puppetlike style of around 1920 gave way

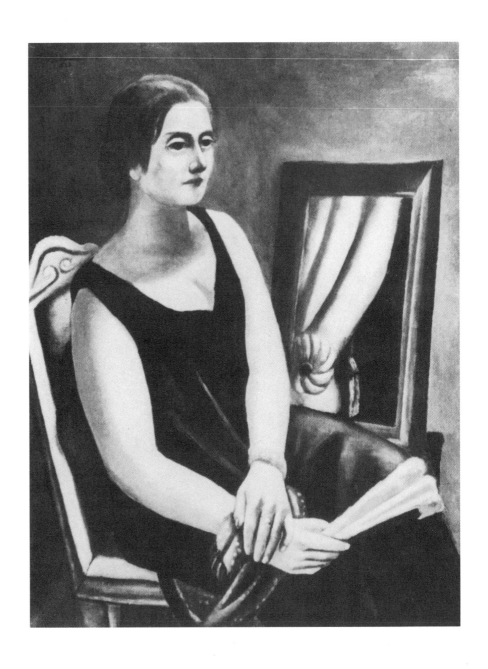

to a shimmering *peinture* of unmistakable French influence. Beckmann now announced the appearance of his "major works."[25] Among these is the *Portrait of an Old Actress* (1926). Julius Meier-Gräfe, who acquired it, lauded the work for unleashing the power of painting.[26] But Beckmann, with a telling peripheral allusion to Picasso in a letter to Neumann written in 1926, stressed the importance of having "achieved a new form of summarizing the essential (from nature, not the Antique)."[27] This does not prevent him from taking a precise look at

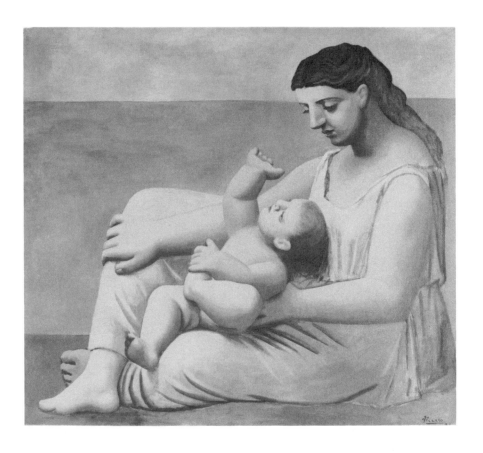

Picasso's classical goddesses. *Mother and Child* (1921; fig. 5), which by 1927 was part of the Reber Collection, offers proof enough.[28] Its influence is evident not only in the aforementioned portrait of Minna, done in 1924, but also in a painting like *Soccer Players* (1929), in which the artistic ideas of Delaunay and Léger have likewise left their mark.[29] Something in these works bordered on the polemical, an intent which after all accorded with Beckmann's striving to establish a place for himself in the history of art, and to defend this position against misunderstandings.

His 1929 portrait of his friend the art historian Curt Glaser (fig. 6) gives ample evidence of the degree to which Beckmann had evolved his new reality of the painting. Glaser, one of the coauthors of the major Beckmann monograph published by Piper Verlag in 1924, as early as 1916 had initiated Beckmann into the expressionistic perspective of late medieval German painting.[30] In the portrait, the scholar is depicted holding a book on his knees and posing like a grand lord. The picture shares nothing with Verism and has nothing of the anecdotal tendency of the portrait painting of the day, evident

5. MOTHER AND CHILD
Pablo Picasso, 1921,
Chicago, The Art Institute
of Chicago

for instance in Rudolf Schlichter's cold portrait of the journalist Egon Erwin Kisch, also painted in 1929.[31] In contrast to this conception of the portrait, which rivals photography in its tendency toward a kind of painted reportage, Beckmann's portrait of Glaser is timeless and yet not coolly distant, warmed as it is by the personal perspective of the artist encompassed in the mask of his style.

At this time, Beckmann was concerned with the reality of painting, its intermediary position between decoration and realism. The differentiation between body and flat, painted surface has not been obscured in the Glaser portrait but rather has evolved into a new synthesis of both. Beckmann sought to depict the essence of Glaser's persona and at the same time to represent an ideal image of his art. The light functions by engendering an internal visual architecture. It scans spatial intervals, which create a rhythm of body and space on the painted surface. Beckmann's interpretative goal here is to establish the nature of the visual order. The Glaser portrait also embodies an artistic program. Shortly before, in 1928, in his "Six Sentences on the Structure of Painting," Beckmann propagated an "art without isms." What he meant was a translation of the three-dimensional space of objects into the two-dimensional space of the painted surface, which was abstraction enough for Beckmann.[32]

Here again is a double attack against two modern schools of painting, from which he distances himself. On the one hand, the tendency toward pure abstraction is blamed for engendering a mere twofold experience of space in the painting, thereby reducing the result to ornament. On the other hand, Beckmann faults Cubism for dissolving the spatial world of objects on the painted surface in a misconceived threefold treatment of space, and for practicing a false motif analysis in which the sentiments of the painter's personality are eliminated. He accords light the primary role of painting, for it binds together the painted surface and permeates the depicted world of people and things, and because it is the painter's primary tool for asserting his own personal interpretation. Color is secondary, since it functions to the detriment of form and space. The simultaneous application of broken tones and pure coloring prevents the colors from separating from the objects depicted and melding into a surface pattern.

We see here how consciously Beckmann labored to establish his place in the ranks of modern art. The "one-horse carriage"—to recall Hausenstein's label—required a heavy dose of polemic to break away from the artistic fashions of the day. Through his painting Beckmann had repeatedly to justify the lofty image he propounded of his own

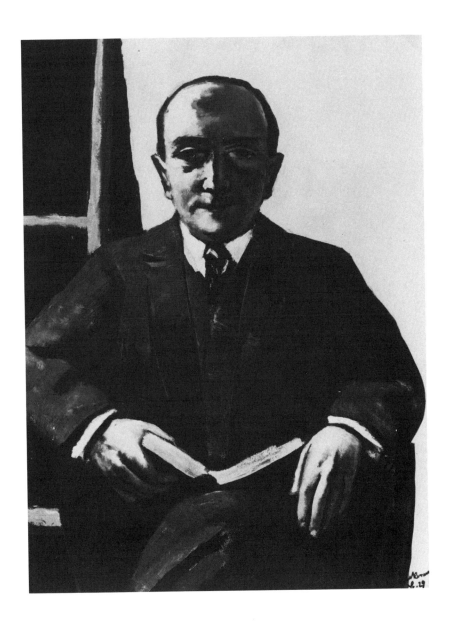

artistry. In this sense *Portrait of Curt Glaser* is Beckmann's program-matic declaration of his place in contemporary art history. Just three weeks after completing the portrait, in June 1929, he finished *Portrait of the Collector G. F. Reber* (fig. 7), this time as a painted statement in opposition to the giants Cézanne and Picasso, whose work was am-ply represented in Reber's collection.[33] In the portrait, Reber is shown as the master of his collection, its presence implied by a costly picture frame in the background. All the colors used are concentrated in his figure, even the red, which is played out in an extended spectrum of

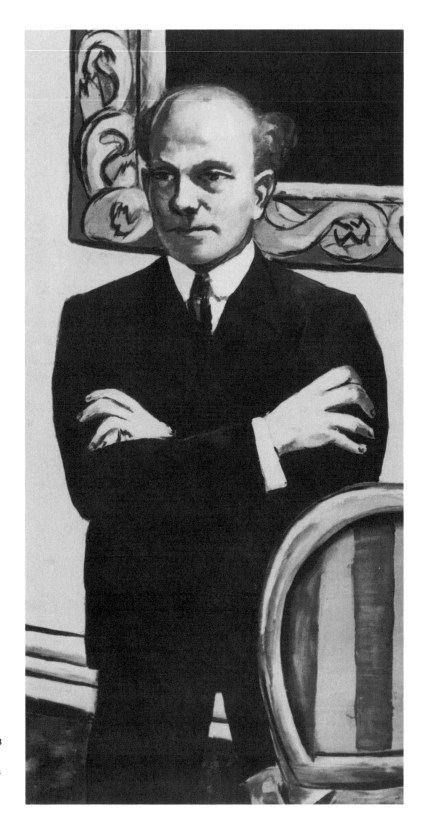

7. PORTRAIT OF GOTTLIEB
FRIEDRICH REBER

*1929, Cologne, Museum
Ludwig (Göpel 306)
140.5×72 cm.*

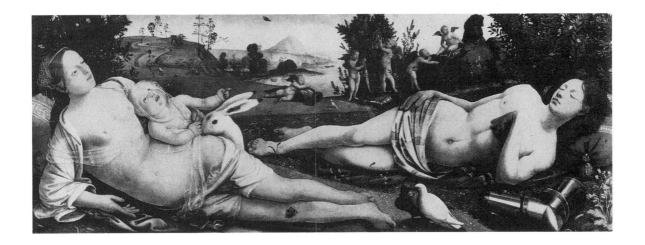

variations throughout the painting. The stance adopted by the person of Reber is similar to Beckmann's own in many of his self-portraits. Thus the artist, the art historian, and the collector have all been sworn by Beckmann to uphold and preserve the sacred precinct of art.

But the mecca of art was Paris, as Reber's collection unfortunately proved. Beckmann was not pleased at the dominance of Paris; his German nature asserted itself. For Beckmann wanted to set the stage with German art. But German art needed to acquire a distinctive expressive stamp, one that would not cover up its characteristic metaphysical tendency with sensual surface flourish. It needed big themes and lofty thoughts. In this double sense of a stubborn imposition of form and meaning, the German art scene of the moment offered Beckmann too narrow a context in which to evolve convincing artistic standards. Instead the old masterpieces hanging in the museums furnished him with his true artistic standards.

It was a Renaissance *cassone* painting, Piero di Cosimo's *Mars and Venus* (fig. 8), in the collection of the Staatliche Museen, Berlin, that he had in mind as a model of sorts when in 1928 he conceived the chalk drawing *The Night* (fig. 9), almost identical in format to that of the Italian work.[34] The theme of the sexes makes its first appearance here, a theme Beckmann was to pursue in the thirties. The nude figures are freed from any private anecdotal allusions and any contemporary context; they are figural archetypes whose universal timelessness serves Beckmann's sense of his subject.

The mythic couple in the drawing has left Arcadia. The bed that stands with its lighted curtain drawn against a dark background functions like a stage on which a drama, the drama of the male, is being enacted. Beckmann's man is no longer asleep, as in Piero di Cosimo's

29

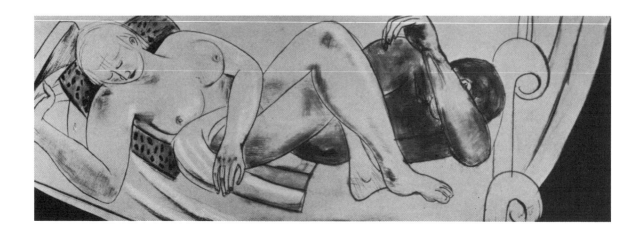

paradise, but covers his dark face with the crook of his arm. As in the apparently anecdotal version, *The Bath* (1930), the light figure of the woman takes up the foreground.[35]

The painting *Man and Woman* (1932; fig. 10) brings the dynamic antithesis of the sexes to a balanced resolution. The man, resembling an archaic kouros, has his back turned to the woman and appears to be looking away, towering over the horizon of the perceptible world.[36] The woman, reclining along the horizon, is bending down to earth, as if to represent Eve after the fall of man. Every element in this painting allows for an allegorical reading, including the two plants or trees: carrying the sexual organs of man and woman like fruits, they are symbols of a plain and humiliating nature. Procreation is assigned to the woman, while the man, who is gazing beyond his own nature, attempts a spiritual liberation.

The Siblings (1933) portrays the mythic couple as a kind of still life.[37] The man is divided into a dark half and a light half. Covering and revealing, separation and attraction are dramatized, in contrast to the monumental nude drawing of 1920 that began the series. By now Beckmann's mythic nude compositions clearly hearken back to a tradition and an aura of art to which he felt devoted. The myth, in its timeless form and universal validity as Beckmann understood it, was also a legitimization of the art he had in mind.

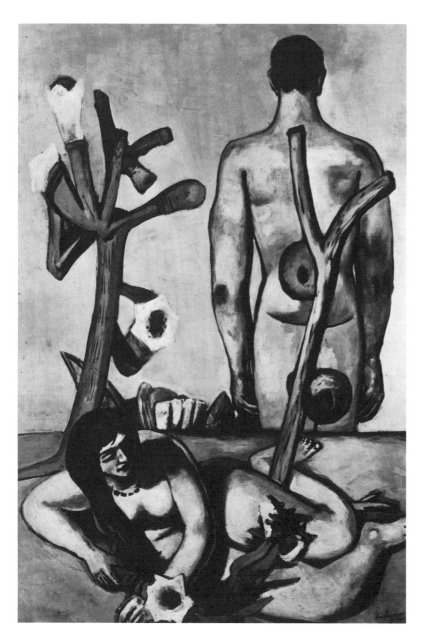

10. MAN AND WOMAN
*1932, USA, Private
collection (Göpel 363)
175 × 120 cm.*

3 THE CLASSICAL REPERTORY

NUDE

The nude is one of the classical genres that, from the early twenties on, Beckmann used to revive the repertoire of an old master—in conscious opposition to the Cubists' veto of the nude, an injunction that, however, had already been transgressed by Picasso and Léger. In the talk "On My Painting" given in London in 1938 (see p. 117), Beckmann referred to the classical genres as literary subjects which he sought to infuse with reality and integrate into modern art by transforming them into form, color, and space.[1] *Sleeping Woman* (1924; fig. 11) launches his series of nude paintings. *Gypsy Woman* (1928; fig. 12) carries it forward.[2] The first is in line with the tradition of a sleeping Venus, the second a Venus at her bath. The two works are related to each other in many ways, including the motif of the blanket thrown over the women's legs. The plump sleeper in the first painting tilts her head backward with an ironic expression on her face, underlining the distance the modern consciousness that created her keeps from the old thematic cliché. The woman has fallen asleep over an open book. She is wearing red stockings. A petroleum lamp lights her reclining form. The illumination thrusts her forward into the painting. A Venetian gold tint spreads a colorful aura around her. The transformation of nature into art is clearly the artist's object.

The same process is reenacted in the later painting, in which the *Gypsy Woman* peers at herself, Venus-like, in a mirror. The old motif is established by the woman's act of combing her hair. Her scanty garments serve to dramatize the body, bathed in bright light. The colors are reminiscent of the luminous tints of the old masters. With the divided background, Beckmann emphasizes, as he often does, the

12. GYPSY WOMAN
1928, Hamburg,
Kunsthalle (Göpel 289)
136 × 58 cm. See p. 65.

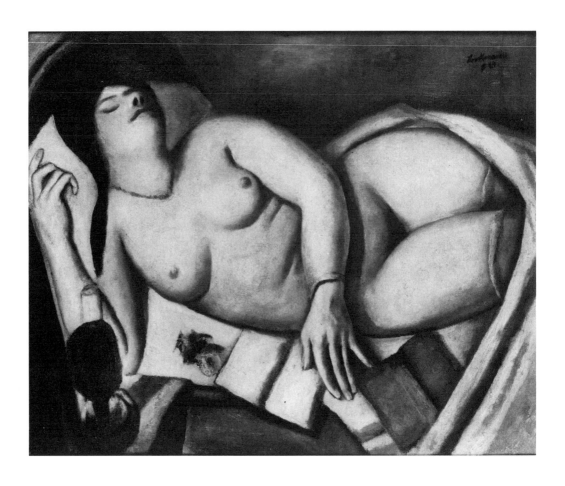

existence and unity of the person against the surrounding space. Light functions as a bridge between the figure and the picture space, as do the gestures with which she draws that space around her. The black ground and the figure's contours painted over in many places accord the old motif particular resonance. Beckmann is here seeking the synthesis of nature and art, so often separated by the German artists of his day. The tonality reinforces the carefully structured chiaroscuro on which the rhythm of the painting is based. The flesh tones of the woman, gradating from the strong light to the deep brown shadows, are unfolded and varied by the rest of the picture. Thus a most subtle interplay of the figure and the painting tends to overcome their difference.

In Georg Scholz's 1927 *Female Nude with Roman Bust* (fig. 13), for instance, the artist takes a stand in favor of nature and against art in the traditional sense.[3] The painting presents a comparison and a differentiation between the ideal of classical art signaled by the bust and the virtually photographic realism of the nude, albeit an unadorned

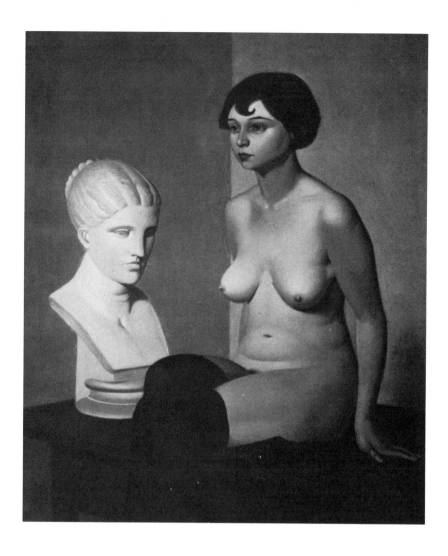

13. FEMALE NUDE WITH
ROMAN BUST

*Georg Scholz, 1927,
Waldkirch, Sammlung
Scholz*

and consummately modern Venus. Scholz's work likewise constitutes a renunciation of a modish classicism, whose ideality was often confused with idealization. The antimodern archaism of this trend was corruptible, as its misuse by the Nazis in the thirties would prove. Beckmann, for his part, made every effort to elude the temptation of the easy idyll; he did, however, on occasion come dangerously close, yet without ever sacrificing the ideal of his art to a vulgar verism.

In this context we can understand the emergence in Beckmann's work of a new, coarse anticlassicism, noticeable as early as 1930 in *The Bath*. The new style was already evident in his graphic work while the artist was painting *Gypsy Woman*. A series of large-format chalk drawings done in 1928, all of which are sketches for oils, leads him to a new, expressive emphasis on the contours of his paintings. He

focuses on the most important part of the modeling, condensing it in a very personal manner. *The Night* (fig. 9) is one of his graphic efforts in which this new method is tested.[4] The artist applies the color more dryly. Black lines reinforce the outlines. The forms are bent into the surface and conceived so as to be integrated with the pictorial space, in the manner of Cézanne and Matisse. But the thrust of this new style tends toward more personal expression. In a lecture on the problems of contemporary painting given in 1931, Carl Einstein said: "The painter wants to assert his control over his motifs by means of deformation. He defends himself against the world around him by a racy brutality toward his motifs." Instead of harmonizing with being, his paintings of that time functioned like direct speech.[5]

The stylistic shift in Beckmann's oeuvre evident around 1930 also encompasses a reappraisal of space. Space in Beckmann's work always reflected both an existential dimension and an artistic significance. The existential dimension mirrors the experience of the individual who, though completely at the mercy of the space that surrounds him, seeks to assert his independent identity. And in artistic terms, space is the means by which the "real terrain" of nature is transfigured into the "painted terrain" of art. This, moreover, is not merely an artistic problem of composition, since for Beckmann art promises a way out of his own human dilemma. What he manages to formulate in a new way is in fact an oddly idiosyncratic regression to the early practices of painting. The painter wields a willful mastery over the things he paints, to transform them into the essential parts that would make up a logic of painting. In *Man and Woman* (1932; fig. 10) an altogether discontinuous space gives free reign to a symbolic interpretation. Beckmann's metaphysical philosophy leads him to insert "that other space" which he used to define the realm beyond and behind the empirical world, namely, eternity. The motifs of the two plants on the desertlike floor attest to the influence of Surrealism, which Beckmann, however, characteristically turns to his own use.[6] An essential difference separates Beckmann from the Surrealists, who were principally concerned with the anarchic life of the psyche or inner self. For Beckmann myth was more important and meant looking back at an archaic existence that had been buried under the rubble of modernity.

LANDSCAPE

Beckmann followed the same path of development with landscape until here too he managed to formulate a metaphysical world view. He took up landscape along with nudes, portraits, and still lifes in the early

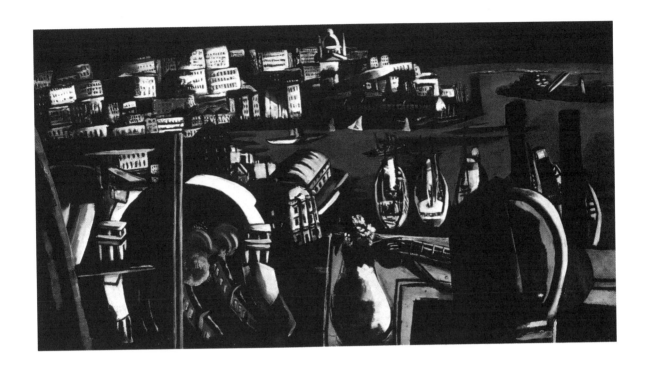

14. THE HARBOR OF GENOA
1927, St. Louis, The St.
Louis Art Museum
(Göpel 269)
90.5 × 169.5 cm.

twenties, working initially under the influence of Henri Rousseau (see p. 21). In a conscious retreat from the virtuosity of his own early Impressionism, Beckmann learned to spell out a whole new alphabet of nature, which, as Paul Westheim said at the time of Rousseau, offered a direct experience of being and being there. It was a way to transcend the time-worn conventions of landscape painting.[7] In his lecture "On My Painting," Beckmann recalls Rousseau, "that Homer in the porter's lodge whose prehistoric dreams have sometimes brought me near the gods."

The Harbor of Genoa (1927; fig. 14) is one of the most important landscapes of the twenties.[8] This horizontal painting has almost the same large dimensions (90.5 × 169.5 cm) as the vertical esoteric painting of 1926, *The Bark* (180.5 × 90.5 cm), and is a similarly ambitious work in a different genre. The painter now begins to interpret the world which he has only just mastered. The colors emerge from the dark underpaint. The moonlight that glows green from the water's surface and flows white-tinted over the painting's solid contours gives body and character to the objects depicted, while leaving their mysterious essence intact. The city appears to swim on the luminous surface of the water, beneath the dark night sky. The painter studies the city from the height of his hotel balcony. To the left, high over the train station, a curtain flutters in front of an open hotel-room window. To

15. EVENING ON THE
TERRACE, SCHEVENINGEN
AT SUNSET

*1928, New York, R.
Feigen Collection
(Göpel 296)
95.5×35.5 cm.*

the right, on the balcony, a still life with vase and mandolin appears,
transcending the genre boundaries of landscape. Even the chair, over
which a scarf has been tossed, attests to the presence of the narrator,
who is observing the world like a hotel guest. Associations with Gior-
gio de Chirico's *pittura metafisica* suggest themselves, both in the enig-
matic lighting and in the shape of the chair, which reminds one of the
Italian painter's mannequins. But Beckmann's light-and-shadow play
is different in a fundamental way from de Chirico's. Beckmann's land-

scape is not meant to be taken as an internal image of a hermetic dream scene, but rather seeks its mystery in the empirical world, which is enigmatic enough for him. The harbor landscape is understood both as the symbol of this world and as the record of a personal travel memory. HIC FUIT might well have been inscribed on the balcony.

The series of landscape paintings of Scheveningen, done in 1928, extend the dialogue between the painter's voice and the world. They too are mostly hotel paintings of an almost documentary exactness, and yet all of a very personal conception. Benno Reifenberg devoted an essay of great literary merit to the seascape *Scheveningen at Five A.M.*[9] A week after finishing the first painting, Beckmann completed *Evening on the Terrace* (fig. 15).[10] The evening painting carries to an extreme the conscious staging of the distance viewed from up close. In its compression into a small, hand towel–like format, and in the enclosure with railing and posts, the observer's stance is established clearly. He looks out on the distance of the evening sea, behind which the sun has sunk between high columns of clouds; his view is framed by the supporting posts of the hotel terrace. Down below, streetlights are being lit. Tiny human figures people the low-lying beach, over which a beam of light falls. The inhabited world of civilized modernity, in which the hotel guest is visiting, is but the foreground for a depiction of the vastness of nature, which pursues its own rhythm in the cycle of night and day. The painting functions like a window, an analog to the eye, which reveals to the painter an experience of the world.

Woman Meditating by the Sea (1937; fig. 16), which was later acquired by Mies van der Rohe, transposes the subject into a metaphor of the metaphysical world view, not yet developed in the earlier landscapes.[11] If the issue until then had been the antithesis of the self and world, a third factor now came into play. The "mythical edge of the world," to borrow a phrase from Hans Blumenberg's *Arbeit am Mythos*, takes a more prominent place in the consciousness of the observer-painter.[12] Landscape and figure painting are combined into one. We appear to be standing on the same terrace as in the Scheveningen painting of 1928. The iron posts and the railing are familiar motifs. The sea is still there, but now it is as motionless and timeless as the sky above. The woman, whose attributes are a book and a large crystal ball, the mantic sphere, rests in her delimited realm, musing on the unchanging amalgam of another space, which the painter indicates as the background of the world. By giving nature a sense of distance, man transcends the world in which he has been placed.

39

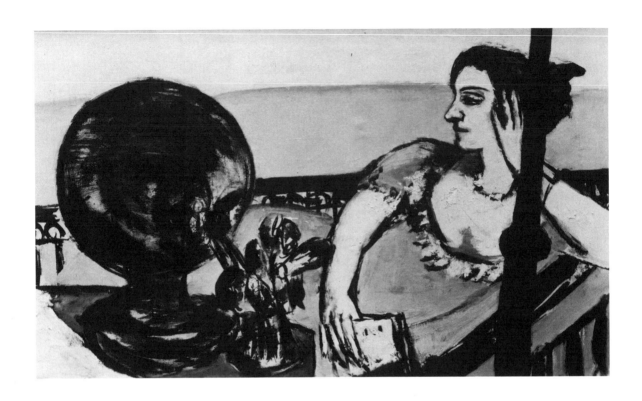

16. WOMAN MEDITATING BY
THE SEA

*1937, Bremen, Kunsthalle
(Göpel 460)
65.5 × 110.5 cm.*

In *Seashore* (1935; fig. 17), a work once in the Lilly von Schnitzler Collection, which Benno Reifenberg praised as one of the "greatest landscapes of the century,"[13] the painter describes not a natural slice of life but a romantic experience of nature in the mood of Caspar David Friedrich's *Monk by the Sea*. The stormcloud that looms in front of the pale sun and the sideward-surging sea introduce a drama that remains hidden in the background and therefore impels the observer's gaze back upon himself. Here, where we cannot take refuge in iconography or references to literary subject matter, the demands of Beckmann's art are essentially even greater, and here, in the anachronism of a romantic nature-vision, his painting compels acceptance or rejection. Mondrian gave up such landscapes early on in his career; Picasso never painted them. To the Cubists, they constituted an unrepeatable genre of the past. The Surrealists replaced them with seascapes, which conjured up only inner images of the psyche. Beckmann alone held stubbornly to the enduring life force of tradition, and sought to realign the experience of nature and worldly experience within the scope of modern vision.

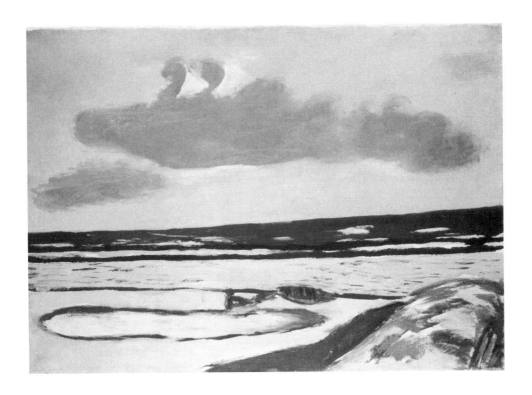

STILL LIFE

In the still life, a classical genre that was to have an important place in Beckmann's repertoire, matters were altogether different; the genre's propensity for a detached, nonsubjective analysis of depicted objects had made it a favorite form for modern painters ever since the advent of Cubism. Consequently Beckmann devoted particular attention to it, to demonstrate his understanding of art in a manner that would be readily apparent in the work. Early in his career he had already energetically formulated a counterposition to the modern artistic dogma espoused by the French, by employing still life symbolically, in the manner of the old Dutch masters, and combining it anecdotally with details from his own biography. Beckmann, the theatrically inclined painter, chose not to deny the sentiment of personal expression. He did, on the other hand, integrate Cubist ideas that agreed with his concept of the independent existence of objects in the painting. Time and again he made new attempts to find a synthesis and avoid eclecticism and, above all, to bring the tradition of the still life into an accordance with modern tenets of artistic perception.

17. SEASHORE
1935, Cologne, Museum Ludwig (Göpel 419)
65 × 95.5 cm.

41

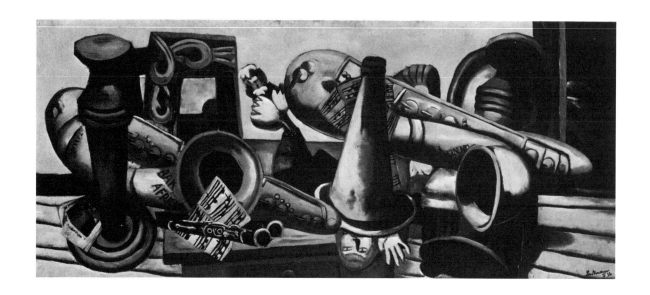

We can observe the painter here through new variations on a theme, continuing the restless search for forms conducive to the expressive realization of his ideas. Each new work in the genre is meant to corroborate his own place in art history. But no single still life offers an all-encompassing solution with universal relevance beyond the specific solution. Only the entire series of works does justice to the demands the artist placed on his painting. Each still life, each individual realization of his artistic program in this form, corrects and adds to the one before. But the program as such is perceptible only in the path that Beckmann followed. This is a prototypical problem of modern art, particularly marked for Beckmann in light of his conflict with schools and isms with which he was ready to take issue but never to identify. The program he envisions, however, encompasses an artistic melding of tradition and modernity, a conception that puts at risk his own raison d'être in the ranks of modern art history. In a surprisingly decisive way, his notion of art allegory finds effective expression in the still life, a form so little suited to it.

The first high point of his achievement in this genre is *Large Still Life with Musical Instruments* (1926; fig. 18), which hangs once again, after its removal by the Nazis, in the Städelschen Kunstinstitut in Frankfurt.[14] By its size (85 × 195 cm), which surpasses that of the still lifes that preceded it, the work proclaims a *maniera grande*, dropping the artistic gauntlet to the French in this domain. But the extremely squat, horizontally elongated format attests also to the problem of space with which Beckmann had to wrestle in those years. The artist seeks to confront such material limitations by filling as small a painted

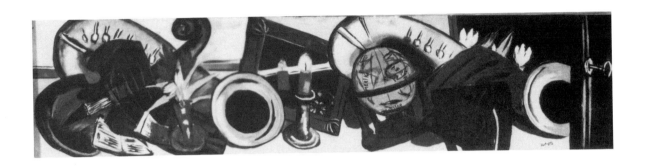

19. STILL LIFE WITH MUSICAL
INSTRUMENTS

*1930, formerly Frankfurt,
Friedrich Ebert Schule
(Göpel 338) 84×360 cm.*

surface as possible with as many objects as possible. And he trans-
forms the vertical format of earlier still lifes into a horizontal one. This
permits the viewer to concentrate on table and floor and by such prox-
imity deflects his attention from other zones. This tendency is even
more extreme in the still life that Beckmann was commissioned to
paint by the Frankfurter Künstlerhilfe in 1930 for the Friedrich Ebert
School (fig. 19). It is almost the same height (84 cm) as the earlier *Still
Life with Musical Instruments* but is drawn out twice as wide (to
367 cm). The painting was devised as a *Supraporte*, that is, to be hung
above the door, and it satisfied Beckmann's secret wish to emerge with
his art from the limited circle of his milieu into the public domain,
and thus to have an influence upon it.[15]

In the still life of 1926, the format has been compressed, as have
the landscapes in that same year (in 1928, the painter cut down his
1914 work *The Street* to the same size).[16] The effect expresses a
conflict between the objects depicted and the space they take up. In
1931 Carl Einstein (see p. 20) accused the painter of wavering "be-
tween a subdued modernism of spatial sense and an often persnickety
academicism of figure and detail." But the problems are far more
complex. Beckmann sought in the alogical, autonomous order of the
objects depicted (an order in which they preserved their identity) an
alternative to Cubism; yet he cancelled the space around them or
transformed it into a purely formulaic style. The relation of the objects
to each other and to the space that surrounds them no longer makes
any conventional sense. This visual arrangement is consistent with
French tendencies. But the objects themselves resist. Instead of melt-
ing into the painting's surface, they maintain an aggressive plasticity
and many-sided presence. The two balusters, although we see the left
one from above and the right one from below, fold forward and back-
ward respectively. The space in which they would ordinarily fit has
been eliminated. As a result, the objects themselves appear all the
more dominant and expressive, for not even the painted surface con-
tains them. They set into motion their own rhythm of interplay, the

20. STILL LIFE WITH
GRAMOPHONE AND IRISES

1924, Private collection
(Göpel 231)
114.5×55 cm.

expression of which has a direct and unimpeded effect on the viewer. Thus the "life of things" in Beckmann's still life acquired a new idiom.

Here we have a table. Its legs stand beside it. They look like the two balusters, one propped up on the floor, the other leaning against a chair. By performing an inanimate drama of sorts with diverse roles, they constitute a polemic against Cubism, which focused on multiple views as its main purpose. As objects unadorned, the balusters likewise embody a critique of Fernand Léger's obsession with balusters and the rationalism of his machine style.[17] Two massive saxophones are clearly characters in the play. With their curvy motions, they traverse the space around them, which, since it lacks its own identity, offers no resistance to the instruments. On the table lie flutes and a pad of sheet music. A megaphone has been propped up over a doll, as if to amplify its voice, while simultaneously appearing to suffocate the little emcee. In a mirror to the rear the sun is rising. And to the right the ghostly visage of the night peers into the jarringly lighted room.

The Frankfurt still life functions not only in the surface structure of the work; it also embodies a program for Beckmann's art. The message begins with the inscriptions on the saxophone. The one to the left says "Bar Africain," implying that it plays jazz, not Wagner. In the almanach put out by Piper Verlag in 1924, Beckmann permits himself a capricious remark: "I love jazz so much. Particularly because of the cow bells and the car horns. This is such a sensible music. We could do so much with it."[18] Thus the painter's message becomes more apparent. The megaphone and the saxophone are droning car horns. And the flowers in the vase are the encoded cow bells, which is just what people call them colloquially. Thus, to begin with, the painting reads like an allegory of jazz.

If, however, we pursue our interpretation one step further, we discover the analogy between jazz and Beckmann's painting. The inscription on the second saxophone gives us the clue. "[Exhibiti]on New York" refers to Beckmann's first exhibition in the United States, which opened on April 12, 1926. At the time, the artist was still at work on the painting. The musical instrument in Beckmann's oeuvre is often the symbol of art (see p. 63). Here it refers to the international fame of his art, above all to its *modernité* in the sense of jazz. *Still Life with Gramophone and Irises* (1924; fig. 20) already contains autobiographical references. Such allusions reach back to the small *Still Life with Burning Candle* (1921), which turns out to be nothing other than the abandoned scene of his painting *Carnival* (1920): even the cigar box is still lying on the table.[19] The 1924 still life is quite literally a

45

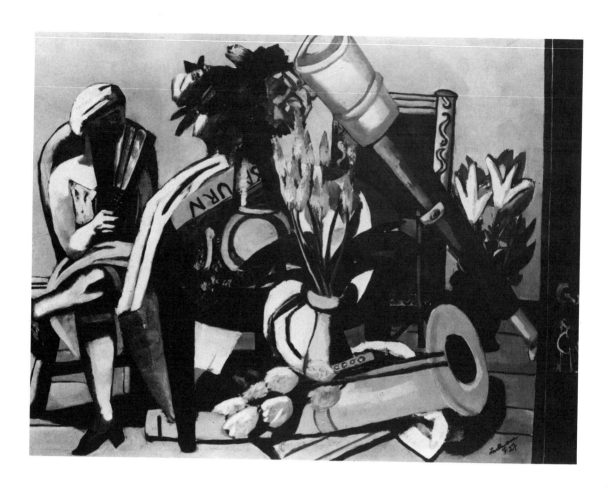

"souvenir of Frankfurt," as is inscribed on the vase. An autobiographical subtext is built in here. A man's carnival mask lies on the chair. A woman wearing her mask appears in the mirror. Man is present in the objects that function like the props of a stage play. The lute on the table—a topos of the Cubist still life—refers to the old music, the gramophone on the floor to the new. Once again, we find an allusion to the opposition tradition versus modernity.

The Frankfurt still life of 1926 is an outspoken confession of the modernity of Beckmann's art. *Large Still Life with a Telescope* in Munich (fig. 21), painted the next year and considerably larger (207 × 141 cm) than the Frankfurt still life, is also an allegory of art, but this time an allegory with an accent on tradition, as if it sought to reestablish the proper balance. The metaphoric reference here is not to music but to seeing, opening, and revealing. Beckmann incorporates an artistic quotation, taking both the woman with the fan and the telescope from Jan Brueghel's *Allegory of the Five Senses* in the Prado, which is really an allegory of art.[20] Such motifs in painting, which for

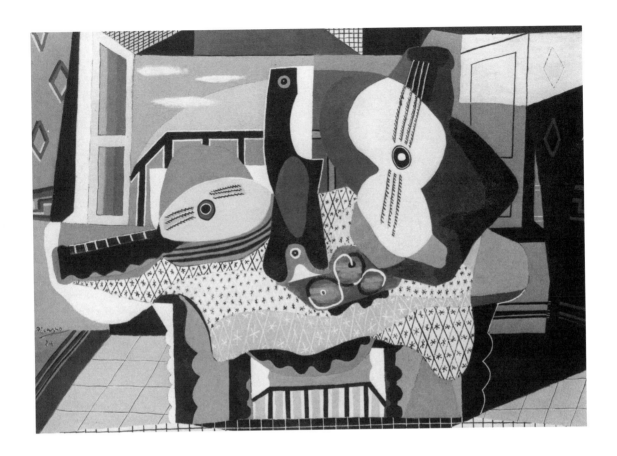

22. STILL LIFE WITH
MANDOLIN AND GUITAR
*Pablo Picasso, 1924,
New York, Solomon R.
Guggenheim Museum*

their part already point to tradition, are supplemented by the inscription "Saturn" gracing the rim of a chart with the signs of the planets. It is under the sign of Saturn that the melancholy genius, the artist, is born.[21] The painting has been read by some interpreters to contain a program of an esoteric purpose, binding destiny with the stars and introducing the secret riddle of life.[22] Here it suffices to point out the allegory of art. Art is in any case Beckmann's life purpose. The open door with the bunch of keys may likewise allude to the mystery of art, to which Beckmann was devoted.

In formal terms, *Large Still Life with Telescope* is the next stage in the integration and metamorphosis of Cubism in Beckmann's oeuvre. The montage of the black table with the gaudy flowers, a kind of picture within a picture, functions like a quotation from Picasso's still lifes of the twenties. The deep, rich colors and the sharp shadow contours likewise recall the same source. The flat layering of objects disrupts the surface unity of the painting. In Picasso's *Still Life with Mandolin and Guitar* (1924; fig. 22), which was in the Reber Collection in Switzerland and today hangs in the Guggenheim Museum in New York, the objects depicted seem to leap right out without the use

of any illusionist tricks.[23] The eye is convinced by color and contour alone. In opposition to the decorative tendency he finds in Picasso, Beckmann holds to a stubbornly preserved independence of depicted objects, giving them something of the symbolism of the old Dutch masters. In this way he not only announces his artistic self-image but also emphasizes that the objects maintain their own identity only through the expressive significance that he, Beckmann, gives them.

It would take us too far afield to follow the development of his still lifes all the way through the thirties. This further evolution again involves his antitheses to Cubism as well as new allegories, which occasionally assert themselves with a highly dramatic pictorial staging. The Hamburg *Large Fish Still Life* (1927) had already been started when the Munich *Large Still Life with Telescope* had not yet been completed.[24] The table functions like an easel with outspread picture frame. An Italian newspaper, a Cubist theme, lies beneath the lavish fish bodies, without signifying any overt collage. Musical instruments, which surely have no bearing here, are deliberately forced into the picture. The Detroit *Still Life with Fallen Candles* (1929)[25] has the effect of a stage tragedy and is conceived against the same divided background as that of *Gypsy Woman* of the previous year. With motifs from Cézanne (such as apples on the table) Beckmann assembles a dramaturgy altogether true to his own spirit. The Karlsruhe *Large Still Life with Candles and Mirror* of the following year[26] makes a complete about-face in response to the previous still lifes, but maintains the pathos of the moody self-portrait of the painter, a topos Beckmann inserted in his still lifes from the very beginning, completely ignoring the boundaries of the genre. And the panel above the door of the Ebert School, painted in 1930 (see p. 43) and destroyed during the war, which is very consciously linked to the Frankfurt painting of 1926, rounds out the series. Here again is the open door, and Beckmann himself is peering out of the mirror between the saxophones. Thus still life made a marked contribution to Beckmann's sense of art, which was after all indistinguishable from his sense of himself as an artist balancing tradition and modernity.

4 THE ARTIST IN SOCIETY

Beckmann's search for a position in art history, which in the twenties served as the guiding thread of his development in the traditional genres of portrait, landscape, nude, and still life, was not the sole focus of his burgeoning artistic identity. His reflections on art, which as we have seen evolved into full-fledged art allegories, were infused with the conflict between tradition and modernity. Beckmann defends an old concept of art; his efforts, which extend even to the remythification of subject matter in his paintings, are all directed against what he perceived as art's secularization, which in Dada took on a literary and in Bauhaus a technological form. This secularizing trend sought above all to tear down the wall between art and life, to surrender art to life. Beckmann followed the opposite course and promised redemption through art. This side of Beckmann's artistic identity focused on the role the artist ought to play in society. An outright messianic sense of mission—an artistic messianism that goes so far as to assume all the suffering of his times—justifies the titanic magnitude of his paintings and their ambitious scope.

It is above all in his texts and his self-portraits that Beckmann gives programmatic expression to this aspect of his artistic identity. His idea of the artist's role in society was based on an intellectual tradition before Beckmann's metaphysical world view took shape in his oeuvre and before the artist had declared himself as the prophetic vehicle of that view. In his self-appraisal of the artistic genius as a Promethean figure, the conflict between tradition and modernity is replaced by the conflict between the individual and the world. It is a common conflict, and especially in literature is a dominant theme of the modern consciousness (see p. 82). For Beckmann, not only is this issue colored by the intellectual tradition of German idealism, in which the painter felt thoroughly at home, but it is also made all the more acute by his

sense of the artist's role, his firm belief that his humanity is indissolubly bound up with his artistry.

Beckmann's claim for the artist was formulated at its most extreme in his short text "The Artist in the State" (1927), conceived in the wake of his first personal crisis, at a time when the future still seemed to offer room enough for utopias.[1] Beckmann felt that the transcendent idea of man as an autonomous being who believes in himself and frees himself from metaphysical constraints should be realized in art to such a degree that life has no choice but to follow its example. "Art is the mirror of God embodied by man." Art offers humanity a model to follow for the cult of equilibrium needed between external limitations and absolute freedom. "Deification," in Beckmann's text, is synonymous with a godlike autonomy of the individual. Then the text proceeds to a further argument. "What we're missing, then, is a new cultural center, a new center of faith"—a locus for the belief in ourselves, the cult of our own existence. According to Beckmann, the elegant mastery of the metaphysical ought to be expressed externally in the social uniform of a cultural priest, in tuxedo or in tails. The utopian aspect is that the barriers of the social and economic hierarchy are supposed to fall, and the artist is supposed to lead society by his example to a kind of aristocratic Bolshevism, in which only the cultural elite still counts. "Bolshevism took the first steps toward the fulfillment of this vision by the state. Yet what Bolshevism lacks is art and a new faith"—which can mean only that the Russian artistic avant-garde is not to Beckmann's taste as an artist and that collectivism under the aegis of the party does not conform to the needs of the individualist Beckmann.

This glance at Russia, where the hopes of the artist were soon to be gruesomely disappointed, is instructive. It is a look at a utopia in which the artist takes on the public task of reforming society. As early as 1918, in his "Creative Confession," Beckmann expresses his "mad dream . . . to make a building for my paintings," a tower erected to satisfy the longings of man, "a new church."[2] And around the same time he wrote to the publisher Reinhard Piper in regard to his monumental painting *Resurrection II* that he wished "to paint four more such large-scale canvases, and to have a modern meditation hall built to display them. Wilhelm II will surely not appreciate my art. I set my hopes, therefore, on a German republic."[3] Yet Beckmann's dream of being accorded public responsibilities in the Weimar Republic was disappointed in such a fashion as to explain the bitter artist's gradual withdrawal to an inner private world.

At the same time that he wrote "The Artist in the State," Beckmann wrote a brief satire, which in fact is both a pendant to the former text and an essential key to its comprehension. The satire is entitled "The Social Stance of the Artist," allegedly written "by the black tightrope walker."[4] It has remained unpublished until recently. Its subject is the classic case of the artist's alienation. The painter depicts himself here as a plaything kicked around by society, above all by the collector and the art critic. In ten maxims, Beckmann ironically demands of the artist a respect for money and power and a veneration of critical authority, since he, the artist, is nothing but a subservient member of society. The public expects him to entertain, as is the duty of "the merry little artist folk." Above all, Beckmann demands with tongue-in-cheek irony that the artist must know nothing of religion, politics, and life. Only then can he be a harmless thread in the fabric of society. In contrast to the picture of the artist's actual role in society, which "The Social Stance of the Artist" caricatures, "The Artist in the State" presents the utopian dream of an ideal role for the artist in society. In this dream, art is conceived as playing a central role in the vision of a universally sought-after regeneration of society.

A mere ten years later, the painter had no more cause to harbor such a dream. In September 1936, he read the new book by the Dutch cultural historian Johan Huizinga, *In the Shadow of Tomorrow: A Diagnosis of the Cultural Sufferings of Our Time.*[5] Outside Germany it was still possible to dream of another kind of regeneration of the society everyone viewed as corrupt. Huizinga's claim that a new spirit was needed applied to various domains. Progress and science were riddled with doubt. Huizinga called for a transcendent faith in a salvation beyond the terrestrial. Beckmann added in the margin: "beyond the imagination." Huizinga saw the salvation in a new ethics, in a new asceticism. The rift between collectivism and individualism had to be transcended. At that point in the text where Huizinga asked whether it is an empty dream to hope that the world can still become good, Beckmann jotted down the following: "The world will never become altogether good, but that isn't really necessary." Beckmann's longest entry accompanies a passage in the book that deals with the role of the state. Huizinga calls for a reshuffling of the social order, but asks if the salvation should not rather come from an inner self-purification of the individual and not from any interference by the powers that be. It is in this context that Beckmann adds in the margin the much-quoted comments: "The will to transcendence is the sole possible solution, but hardly for the state. Not necessary anyway, since every form

of government merely offers the stuff of conflicts which each individual personality must solve anew again and again for himself. There is no universal solution, only an individual salvation."[6]

Toward the end of the book, the positions of author and reader appear all the more clearly divided. Huizinga appeals to youth "not to let the world sink in the morass of haughtiness and deception, but to reinfuse it with *Geist*." At this juncture in his reading of the text, Beckmann must have decided to send the book as a gift to his son, noting in the margin: "Now then, dear Peter, I recommend you have a look at some Kant, *Critique of Pure Reason* (very important), and a lot of Schopenhauer." Such advice can hardly offer a program of action for the future. It is to be taken in the spirit of the lengthy notation that precedes these words to his son. Beckmann, as artist, finds in his art what Huizinga asks of youth. His self-image as an artist is rooted in an intellectual tradition that also suggested the artist's role in society. A brief consideration of that tradition is thus called for, before we examine what social role the artist plays in the world of Beckmann's paintings.

The "transcendent idea" to which Beckmann makes reference in 1927 he had called "transcendent objectivity" in 1918; it derives from intellectual traditions that can be traced back to Beckmann's favorite philosopher, Schopenhauer. In *Parerga und Paralipomena*, a copy of which the young Beckmann already owned, Schopenhauer speaks of a transcendent fatalism, in light of which the world, which is mere idea, can only be endured.[7] The only reality is the life of the individual. It is the metaphysical, which exists undivided and in its entirety in every individual, that vanquishes nature. Our final purpose is rooted only in our eternal being, which transcends each individual life. Life is a condition of suffering and purification. At the end, when the journey of the soul has been expiated, salvation comes in the form of death. The dream of life, in which everyone is the secret theater director of his own dreams, is synonymous with the will to live; its transcendence is the final goal of our temporal being. The ideal is our cognitive faculty, autonomous consciousness itself, which stands in perennial conflict with the life of the real. It is in this intellectual tradition that Beckmann's notion of self as an almost sacred being is rooted.

The "artistic metaphysics," as Nietzsche himself referred ironically, in retrospect, to the ideas of his youth, is part of another tradition, exemplified by *The Birth of Tragedy* (1872), and also by the musical

oeuvre of Wagner.[8] This Nietzsche-Wagner–inspired metaphysics evolved a messianic claim for art, which such diverse spirits as Stefan George and Vasily Kandinsky took up, and which, despite Beckmann's occasional differences with Nietzsche, continued throughout the painter's life to be deeply embedded in his aesthetics. As early as 1924, Beckmann spoke of a painterly music, whereby "music," according to Nietzsche's use of the word, stands for ecstatic art in general, art that releases the individual through a mystic experience of unity, from the constraints of the world and the shackles of rationalism.

Beckmann's definition of art as disciplined rapture, a notion he expressed in 1948 in "Letters to a Woman Painter," is the most concise possible formulation of Nietzsche's construct of Greek tragedy composed of an Apollonian half and a Dionysian half.[9] For Nietzsche, the ecstatic music comes before language. Its newborn genius took hold of the dying mythos and allowed it to blossom again as the wistful premonition of a metaphysical world. In the era of theoretical man, the regeneration of a metaphysical art continues to be necessary. The self of the lyric poet has a greater propensity than anyone else to peer into the heart of things. Nietzsche's artistic metaphysics culminate in the famous line that the world "can be justified only as an aesthetic phenomenon." We can learn something about the eternal body of art only if, "in the act of artistic creation, the genius becomes one with the primal creator of the world." The antirationalism that beckons the artist to bear witness against the world remained as important to Beckmann as did the self-proclamation of the creative genius to be the guardian of primal truths and the redeemer of the alienation suffered by man. While the avant-garde hastened the advance to the future and not infrequently also sought to liberate man from the irrational dependence of art, the opposite direction is followed in the Nietzschean tradition. The artist is expected to offer the individual precisely that which modern society denies him: identity and a mystical tie to the secrets of the world.

Beckmann's remarks about his art are always rooted in the context of this aesthetic metaphysics. "What I want to show in my work is the idea that hides itself behind so-called reality," Beckmann said, true to Schopenhauer's theses.[10] Art serves perception, not entertainment, but what he means is a mystical perception. This is why he sought to transform the optical impression of the world of objects by means of a transcendent mathematics of the soul. In opposition to the collectivism

of the modern era, which threatens the identity of the individual, he invites the viewer of his paintings to follow the path of discovery to the self, "the great veiled mystery of the world."[11] In "Letters to a Woman Painter," Beckmann says we must defend our faith in our own individuality and in our transcendent possibilities against the great bane of modern times, exemplified for him by the car, the photography, the cinema.[12] It is high time to examine this antimodern stance in Beckmann's art as well. It was his view that the "will to form" already embodied the seed of redemption. In his dreams that led him back to archaic cultures, Beckmann discovered the deepest feeling for the mystery of being.[13] In a 1932 letter to J. B. Neumann, the painter writes that over the next twenty years he will undertake to "set mankind before a new reality. Now more than ever before, we artists are needed, and I will force people to accept art and thus be saved."[14]

The events that followed in 1933 made Beckmann all the more convinced that the will to transcendence is the only possible solution. The role of art is evident here. In 1939, in another letter to Neumann, he says that the artist has to strive as much as he can to accord this ghostly world a reality of image, the one true reality there is.[15] It may be conceded that Beckmann felt himself more real than life. The problem, however, begins when the painter derives from such a premise a general maxim of art, reducing life to a mere negative foil.

Beckmann did not evolve a fully elaborated theory of art, nor for that matter did he ever develop a conclusive theory of life. Of which visual artist have we ever asked so much! Yet Beckmann does participate in a German idealist tradition, a tradition with dark dimensions that would become all the more virulent, the more a tendency to flee from reality in the period around 1930 fostered extreme solutions or a path toward total internalization of life. In this context, Beckmann cannot be viewed as the "one-horse carriage," comprehensible only through a study of the mystical tents of the Cabala. If we are prepared to pursue the evolution of Beckmann's philosophy, to trace his roots and follow his development, it behooves us to take a look at an Expressionist poet rooted in the same intellectual tradition yet who, as a man of words, was all the more susceptible to its aberrant elements. The poet Gottfried Benn (1886–1956) was almost the same age as Beckmann and shared a strong spiritual affinity in some areas, although his thinking was clearer and sharper. The two men never met personally: a meeting was averted by a chance occurrence.[16] Thus the parallels between them are all the more striking. In 1931, in an essay entitled

"Fanatismus für Transzendenz," Benn wrote that he had already developed this fanaticism in his parental home (his father was a Lutheran minister).[17] What he meant was the unwavering conviction to reject every materialism of a historical or psychological nature. Yet for him transcendence veered toward the artistic, as opposed to the religious, culminating in a metaphysics of art. In 1933, in his courageous "Bekenntnis zum Expressionismus," he cast a disillusioned look back at the nihilism fostered by Nietzsche's writings, "for a generation of Germans for whom art was the sole metaphysical activity to which life still bound us."[18] We detect here prejudices that made him vulnerable to the irrationalist seductions of the thirties. These objections were directed against the materialistic-mechanistic world of forms, from which one was to escape into images of deeper worlds, as we read in the 1932 text "Nach dem Nihilismus."[19] Only the autonomous spirit could overcome this nihilism through an altogether transcendent attitude. Only in this way could one engender for Germany an altogether new morality and metaphysics of form. And only then would a new ethical reality reveal itself to the German people, a last way out of the collapse of values. In considering Benn's short-lived entanglement in Nazi ideologies, we touch one of the hot irons of German cultural history. As we well know, the seductive allure of these irrational tendencies had dangerous repercussions. Benn's images of the enemy were shared by Beckmann. As one of the "degenerate artists" stigmatized by the regime, the painter was immune to any compromise with the wrong side. Yet he too believed in the utopia that Benn formulated: "We carry the ancient peoples in our souls, and if the late-sprung rational urge ever loosens its grip in dream and rapture, they will rise again with all their ancient rites, their prelogical thinking, and they will grant us an hour of mystical participation."[20] In 1927, the same year Beckmann wrote his essay "The Artist in the State," Benn published a text with a similar title, "Art and State." Its tenor is different but it shares the same aversions.[21]

From the ranks of critical opposition, Carl Einstein shed light on the antirationalism of the time in his Berlin lecture of 1931 on the problems of contemporary painting.[22] The mythic tendency has returned, said Einstein. He was referring, however, to the Surrealists and their psychographic art, their insistence on the anarchic structure of the collective unconscious, phenomena distinctly contrasted to the archaic aura of the self in Beckmann's metaphysical art. Nevertheless, as a document of the times, Einstein's remarks have bearing on our

subject. The intellect, he maintains, "is but a thin layer pierced again and again by new mythic forces." What we discover here anew are the old forces. Man stands at a distant remove from the reality that oppresses him. Paintings are "deposits of the soul in which a maximum of soul strength" has been invested. "To escape the process of death, we bring paintings into being." Realism is felt as a mistake, Einstein observes, and "we no longer wish to submit to the selective power of reason." This is true, he remarks, above all for art, which is an uncommonly conservative entity, since it keeps referring back to the past. The issues Einstein raises go beyond the scope of our argument. They relate only in the sense that diverse intellectual traditions and notions of art converged in the common horizon of the period around 1930. The path into myth is part of the process. Beckmann was not the only painter to move in this direction. We stumble here onto problems in the writing of art history that cannot be encompassed by a study of the evolution of isms, schools, and individual artists. The attempt to synthesize art history and intellectual history per se leaves us without the help of the common methods developed by art criticism. Nevertheless, it is precisely such an attempt that will shed more light on Beckmann's later career.

In the essay "Die Fabrikation der Fiktionen," written when the catastrophes of history had become apparent to all, Carl Einstein settled accounts with the "shameless genius cult" in the bourgeois aesthetic.[23] With a polemic voice that belongs to a contemporary of Beckmann's, we round out the spectrum of remarks related to our subject. Einstein expressed amazement at man's prodigious longing for fiction and poetry, a longing from which the laws of being are derived. Man is completely boxed in by reflections. When his faith in the gods wavers, he wraps himself up in the cocoon of soul. The "spirits conjured up by him are supposed to answer his questions of Why? and Where to? . . . His sensations are all encompassed by shadows and reflections, which, being derived from man, are more prized by him than the 'things' themselves. The world has thus been reduced to a symptom of our signs," and man can no longer distinguish between fiction and reality. This reproach, formulated as a consequence of a disenchantment with the limitations of the artistic world view, is combined with another reproach. Einstein maintains that metaphysics are merely the derivative of a true faith, and our one-sided understanding of art as an act of creation is merely the result of a modern prejudice. Einstein is definitely not alluding to Beckmann here, although he is attacking convictions central to Beckmann's sense of himself as an artist. In doing this he brings our subject into a profile clearer than all the

ahistorical "appreciations" concerned only with interpreting Beckmann the timeless artist.

We have yet to address the question of what bearing Beckmann's texts have on his paintings. If we restrict our inquiry to the confines of this chapter, our question might best be limited to ask how Beckmann's paintings illustrate his avowed role in society. Two self-portraits, done in 1927 and 1938 (figs. 24, 26), translate what the texts demand, realizing the spoken challenge on canvas. Beckmann's role in society depicted in each is as different as the world with which the painter was confronted in 1927 and 1938 respectively. His artistry in the earlier instance is seen as a model and in the later case as a victim of society. The first painting is euphoric, the second defensive.

If we trace our way back to the years around 1920, Beckmann's role as an artist must be differently defined. The title pages of several series of graphic portfolios support such a conjecture. In *Faces* (1917), reproductions of some of Beckmann's oil paintings are mixed in among the coarse depictions of wartime conditions as though they too were a kind of reportage in another medium. Among these paintings we find two self-portraits, one of which, on the first leaf of the portfolio, presents the painter as a coldly inquisitive, innerly wounded contemporary of the events depicted.[24] In the portfolio *Hell* (1919), a self-portrait of the painter as nightclub barker introduces the terrible panorama of big-city life.[25] On the title page of the portfolio, *The Annual Fair* (1921; fig. 23), the painter leans out, cigarette dangling from the corner of his mouth, hunting for passersby; he is the barker with a bell.[26] The company presenting the show is called Circus Beckm(ann). The barker's index finger is pointing to the bell, or to the circus itself, its program presented live onstage "within," on the pages that follow, that is. One can even catch a glimpse of the unofficial show behind the scenes. The diverse roles of life are presented in the narrative form of a fair. Terror gives way to the ridiculous. The world has gone mad. The cast of characters that appears in later canvases makes its first appearance here.

Beckmann's own role as artist is that of barker. He merely announces, so it seems, whatever is presented onstage. His delivery is a bitter organ-grinder's ditty. We cannot expect to derive any refined artistic pleasure but only to shrink back from the mirror that the artist, with a fool's license, holds up to society, brusquely at first, and later in the manifold mirrorings of theater and circus metaphors. Just like the old court jester, he is allowed to tell the truth with impunity. He

23. THE BARKER (SELF-
PORTRAIT) THE ANNUAL FAIR

drypoint, 1921, plate 1
33.5×25.6 cm.

knows no alternative to the one play but unveils the terror or comedy
it contains. In so doing, he of course makes it *his* play, for the play's
depiction of life is synonymous with the way *he* experiences and sees
the world. There is no contradiction here. With his shrill voice, the
artist sings a parody of the world. What he presents does not derive
from a world of art but remains rooted in the world as it *is*. What
Beckmann introduces with a searing bite is an affront to bourgeois
expectations of art. Art becomes a weapon, an accusation wielded

58

against the world by the agile hand of the artist. At the time, Beckmann concurred with the social critics for whom art had to serve a purpose, and not merely lay claim to its aesthetic autonomy from life.

But the painter's attitude shifted. In the early twenties his sense of the artist's role in society changed to such an extent that he almost went to the other extreme. His new concept, as formulated in "The Artist in the State," is that of an art rooted in tradition and yet superior to society, and as such a higher example, a painted path for society to follow. The first high point in Beckmann's new self-depiction as artist is *Self-Portrait in Tuxedo* (1927; fig. 24), as Beckmann refers to the painting in a letter to J. B. Neumann.[27] It was completed in 1927 and was, as early as 1928, acquired from Julius Meier-Gräfe by the Nationalgalerie in Berlin. Soon thereafter the Nazis removed it. Following various byways it finally landed in the Busch-Reisinger Museum at Harvard University, where German art found a home in the United States.

24. SELF-PORTRAIT IN TUXEDO
1927, Cambridge, Massachusetts, Busch-Reisinger Museum (Göpel 274) 139×96 cm. See p. 66.

The painting stood in the crossfire of contradictory opinion from the very start. The artist's nonchalant pose in formal attire virtually invited misunderstandings. Even the painting's monumentality was a red flag to the bulls of public opinion. The painter seems larger than the viewer himself feels standing in front of the canvas. Beckmann peers out of the painting, hand on hip, his gaze scouring the distance. The cigarette in his hand is a recurrent topos that appears whenever the painter places himself onstage before an audience. He already clasps it defensively and aggressively in the early self-portrait of 1907, in which the young painter, with Florence behind his back, likewise poses in formal dress. Thus the pose does not derive from a convention of portrait photography of the twenties, although Hildegard Zenser's useful comparison does illuminate the work's temporal aspects.[28]

Yet the painting's subject is in fact the transcendence of a merely temporal existence. The use of light supports this idea of a figure in opposition to the world. Painted over the black ground, the lights are one of the key tools at the painter's disposal, above all enlivening the fleshy tints. For the first time Beckmann divides the background vertically into a lighted and a shadowy half. The colors of the tuxedo take up the dualism of black and white, which the painter will later mention in his lecture "On My Painting." The decisive feature, however, is the unity of the figure as opposed to the divided space of the picture. This becomes a metaphor for existence itself. The painting's expressive impact culminates in the heavy and almost archaic head, against

which the light breaks on both sides. The active pair of eyes between remains so much in the shadow that the gaze attains an illusion of distance.

At the time the painting was completed, Beckmann was working mostly on still lifes. His conception of the still life reflected equally lofty artistic demands, and as we saw in the last chapter, Beckmann transformed the depictions of mere objects into allegories of his own art. The sensual quality of color already distinguishes his *Portrait of an Old Actress*, which in 1926 he counted among his "major works."[29] The 1927 self-portrait reaches even further in its ambitious intention. A month before he completed the self-portrait, his text "The Artist in the State" appeared in the July issue of *Europäischer Revue* (see p. 50). He thereby set the stage for the message of the painting. The artist, in Beckmann's sense, is a modern *Übermensch* of the Faust and Zarathustra ilk. He feels himself called to the priesthood of a culture committed to, among other ends, autonomy in relation to eternity. "The new priests of this new cultural center must be dressed in dark suits or on state occasions appear in tuxedo, unless we succeed in time in developing a more precise and elegant piece of manly attire." When he adds that the worker "should likewise appear in tuxedo or tails," such an afterthought cannot dispel the twilight that hangs above the vision of a new society, a further extension of the social status he had already achieved as "painter-professor." The tuxedo functions as a uniform, but Beckmann himself cannot decide on what that uniform should represent. In a short text written for the *Frankfurter Zeitung* in 1928, he writes of a sense of displacement in relation to society, reflecting above all his persistent hope for a new transcendence in the wake of the materialistic epoch.[30] He refrains in the article from revealing the exact nature of "that future form in which I already live and for the fulfillment of which I am waiting."

This ambivalence is also evident in the painted portrait that presents the "new man" in the person of the artist. Beckmann's emphasis has a disquieting effect if compared with, for instance, Georg Grosz's self-portrait (fig. 25) done in the same year, 1927.[31] The Prussian moralist, almost ten years Beckmann's junior, decked out in spectacles and smock, raises a pedantic schoolmaster's forefinger at the world. "The Admonisher," as Grosz called the figure in the portrait, is a dreary social critic who sees nothing that anyone else could not see as well, but lays claim to his analytic power. He is worlds apart from Beckmann the visionary, who in the attitude of the true genius propagates a new existentialism based on archaic memory. The new idea, Beckmann suggests in "The Artist in the State," demands that one take a

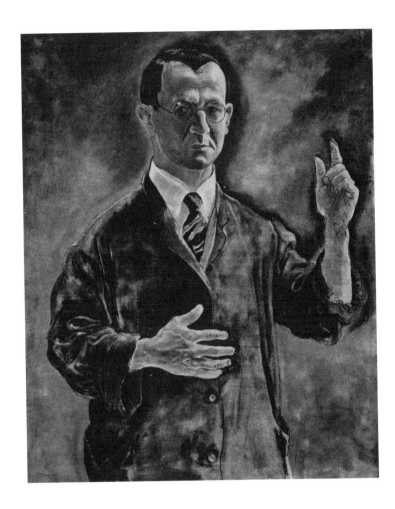

monumental responsibility for oneself. If achieved in the work of art, it will serve as a symbol for future tasks. The crux then is an aesthetic question. Valid answers can be provided only by the individual who is able to weigh the issues and derive his own standards. The artist is the demiurge of a new humanity which acquires a mythic existence beyond the periphery of all the social utopias and social reforms of the twenties, an ideal existence in which the real conflicts with the mass culture of the Weimar Republic can conveniently be repressed.

Beckmann's self-portrait of 1927 is the epiphany of an autonomous genius. The picture is obviously chosen to transfer into art the demands expressed in the programs he espoused. The question remains whether the uneasiness suggested by the texts is likewise evident in our perception of the painted self-portrait. The fascination the painting aroused in those who first saw it is historical fact. The power of its sensual presence is stronger than any programmatic plans. No forced

25. SELF-PORTRAIT
George Grosz, 1927,
Private collection

iconography dispels its effect. The transcendent idea of art, if such an idea becomes visible here at all, has, however, little in common with Beckmann's social-utopian visions. The utopia here is the timeless depiction of man in art, an image for which Beckmann strives in a modern fashion. But in effect it is art alone that Beckmann could maintain is timeless. This very notion of art was disputed then and is still being disputed today. If the painter indeed succeeded in realizing such a lofty purpose, he may not have paved the way for a new society, but he has granted the existent society a glimpse of some "metaphysical consolation," in Nietzsche's sense of the term.

As soon as the last dreams Beckmann harbored of his role in society had turned to dust, the small parcel of reality that society had heretofore accorded him was also retracted. He was able to confirm his artistry only in the context of the enemy image the Nazis had conceived for him, which did after all constitute a reality, even if it still allowed only for an escape within. The suffering painter, exiled in Amsterdam, championed his artistry with more pathos than ever before. In 1923 Paul Westheim had said of him: "His weapon is pathos,"[32] and this remains true in the second crisis of his life. The clown theme returns in his self-portraits. The realm of the clown is the domain of the artist who performs for society and smiles at himself. In 1934, in *Self-Portrait in Black Beret*, Beckmann once again dons this comic costume.[33] With arms crossed against his chest he appears to be warding off the perilous onslaught of society. The Frankfurt professor, dismissed by the Nazi authorities from his position at the Städel School in 1933, returned to Berlin, where the days of his 1927 self-portrait in the Berlin Nationalgalerie were already numbered. The artist now was to survive on the periphery of society, in the milieu of actors and jugglers. Only now did he realize that he had never left that milieu. In 1936 he depicts himself as a seer and magician with a crystal ball and in 1937, having emigrated to Amsterdam, as an escape artist freed from the chains of society.[34] His biographical situation is present in all its contradictions. But following Rembrandt's example, Beckmann the individual still sought to triumph. This too is a traditional role artists have long taken in relation to society.

Self-Portrait with Horn (fig. 26), painted in 1938, sums up his new situation and constitutes the programmatic response to the portrait of 1927.[35] As often before, his painting is the result of the most strenuous effort. The photograph of an earlier version, which the painter must at the time have considered finished, surprises us with the extent of

26. SELF-PORTRAIT WITH HORN

1938, USA, Private collection (Göpel 489) 110 × 101 cm. See p. 67.

the corrections evidently undertaken in the final version. The pentimenti in the painted surface attest to the painful effort of transforming one conception into another. Light plays a more important role, precisely because there is now more darkness in the painting. The space surrounding the figure in the painting is deeper. It is bordered in the front by the barrier of a foreground surface painted in bright red, to the rear by a mirror with a golden frame that shimmers in the darkness. Both motifs were added in the final version. The painter's head is in front of the mirror, which serves as a symbol for the transformation of art. The hand no longer points to the musical instrument, as it had before, but in its implied gesture of pausing participates rather in the act of listening. The face wears a melancholy and a reserve which lend weight to the internal action depicted. The gaze remains turned to the side, directed at the horn, whose cold blue tint reappears in the coloring of the listening ear. The burning red of his striped jacket flutters about restlessly, as though behind the bars of a metal fence. No more thought is given to the independent effect of *peinture*. The excited and sometimes coarse brushstroke focuses attention on the expressive quality of the form. In this second Expressionist phase, Beckmann's painting engages in a spontaneous "act of speech," a blunt statement or outcry. Surprise and participation on the part of the viewer are elicited by means of form.

And yet the painter still evokes a sense of distance between himself and the world, although not as he did in his self-glorifying appearance in the 1927 portrait. At that time, he appeared to have control over the distance. Now he seems merely to suffer it. The musical instrument builds the bridge across that distance, joining him to society. It signals art, whose echo he ponders. Its loud tones can shake up the listener, his quiet tone bewitches. This is no longer the barker's bell of 1921, but rather an instrument of the art he practices. As noted earlier in this chapter, Beckmann understood his painting as painterly music and disciplined rapture in the sense of Nietzsche's notion of music. But art for him is not only effect but first and foremost creation. Thus one can also come up with a different interpretation of the painting. It is the artist who first hears the music of the horn. He first experiences the sound after blowing on the instrument, that is, after producing art. His inspiration is the metaphysical justification for existence. His experience of alienation from society is simultaneously his confirmation for being an artist. Alienation was experienced whenever the tradition of art came into conflict with modernity, and thus it is an ironic twist of history that the attacks against "degenerate art" should have been directed at Beckmann of all artists. Yet these attacks

aroused in him the very resistance to society he needed, in which he sought and found his identity as man and artist. Never in his traditional artist role had he offered society the fashionable progress for which it clamored. His ideal self-image as an artist derived from another time, as did his sense of his role in society. This role is expressed in the self-portrait of 1927 and that of 1938, as differently as the two works view society. In this they also confirm the gist of Beckmann's texts written in the same years: they constitute the painted pendants of "The Artist in the State" and the London talk "On My Painting."

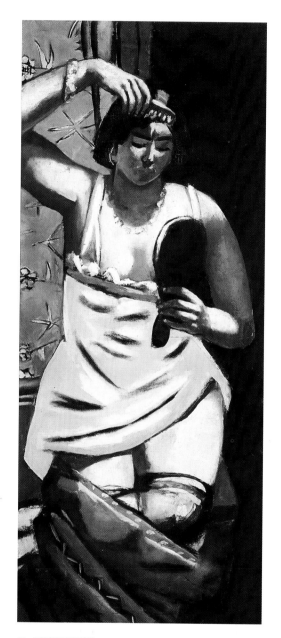

12. GYPSY WOMAN

1928, Hamburg,
Kunsthalle (Göpel 289)
136 × 58 cm.

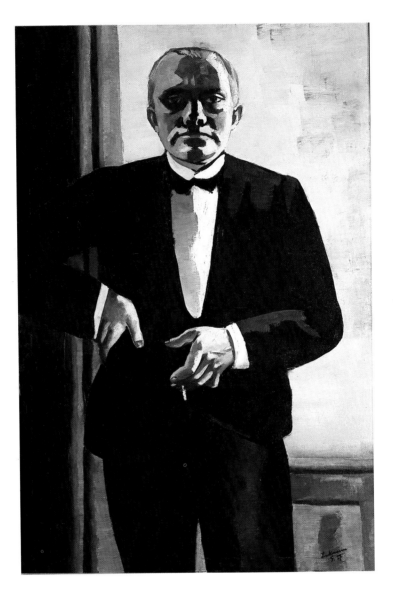

24. SELF-PORTRAIT IN TUXEDO

1927, Cambridge, Massachusetts,
Busch-Reisinger Museum
(Göpel 274) 141×96 cm.

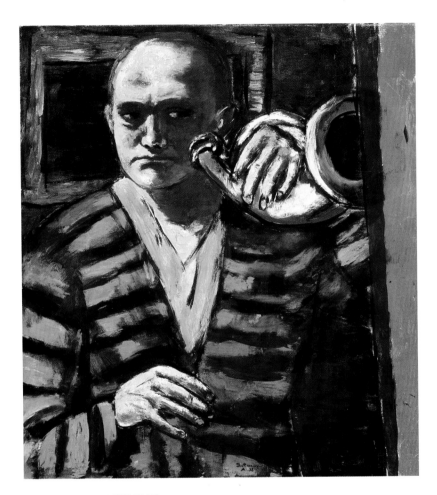

26. SELF-PORTRAIT WITH HORN

*1938, USA, Private
collection (Göpel 489)
110×101 cm.*

43. FALLING MAN
*1950, New York, Private
collection (Göpel 809)*
142 × 89 cm.

5 MYTH IN ART OR ART AS MYTH

The presence of myth in Beckmann's paintings has long been the preferred focus of Beckmann scholarship. We have learned over the years precisely what myths the painter was familiar with. But Beckmann commentators have been less concerned with what these myths meant to him as a painter and how he applied them in his art. The literature on Beckmann sometimes gives the impression that the artist possessed a closed theosophical view all his own, which the paintings merely served to illustrate. The fact is, however, that his philosophy cannot be considered independently of the role it played in and for his art. It is precisely the artist's philosophy that legitimizes the claim his art makes for myth. Insofar as art employs mythic language to treat the myths of mankind, the work of art becomes myth. This is evident in the fact that art forsakes rational control and retreats to timeless archetypes.

We must distinguish between old and modern notions of myth. In its old meaning, myth conceived of the world's secrets in compelling images that predated any logical reasoning. In its modern use, myth is applied to save the world from a surfeit of enlightenment and to abrogate the demands of modern life and society.[1] Beckmann, with this modern sense of myth, promises a redemption from the bare immanence of life and an ordering of everything in its rightful place, against the prevailing impression of a lack of meaning in our lives. This is what William Blake had promised Beckmann in a dream the artist subsequently related in the lecture "On My Painting." Blake tells Beckmann that "everything is ordered and right and must fulfill its destiny in order to attain perfection."[2] These are key words for a modern understanding of ancient myth, which had preceded the modern split between the self and the world. The "right" order refers to man's unity with the world, which the modern individual has lost,

69

while the fulfillment of a rightful destiny refers to an intimate sense of the world that the individual no longer possesses. The first insight facilitates the second. Art was welcomed as the sole clue we still have in the modern era to help us unravel the secrets of myth.

In the same year in which Beckmann delivered those remarks, he made other statements that shed light on his sense of myth. The gallery owner Curt Valentin wrote from New York asking that he explain the meaning of his triptych *Departure* (fig. 27; 1932/33–1935). Beckmann replied that the painting demanded of the viewer an inner coproductivity with the artist and a sharing of the same metaphysical code. Beckmann confesses that the painting tells "truths that he cannot express in words and that he did not know" before completing the canvas.[3] This statement has been often quoted but seldom understood. It is explicable in light of the concept of art as creative act, about which we spoke in the last chapter.

Accordingly, the truth of art cannot be reduced to verbal explanation. The dark mystery of its engendering and of its comprehension by the viewer are one and the same. But what is "the same metaphysical code"? This is the code on which the truth, the rightness, of the painting is based and as a result of which the painting is freed from an altogether private view of Beckmann's own imagination. If such a metaphysical code exists, then it is an antenna for the reception of a deeper understanding, whose transmitter is Beckmann's art. But the code is most certainly not a call to just a few initiates. Only a general comprehension on the part of all viewers can confirm the universal demands of this art. Beckmann's art is as much dependent on this universal comprehension as, conversely, on the idea that myth can be experienced only through the medium of art.

Beckmann is not the only artist to concern himself with myth in the years around 1930. We must take this contemporary trend into account if we wish to understand Beckmann's own version of mythic representation. Remythification was intended as an answer to the prevailing tendencies of demythologization in modern democracy. This was also true of art whose previous demythologization and reduction to an aesthetic phenomenon had become a dominant issue in the critical discussion of the period. Enlightenment and science had replaced ancient myth as explanatory systems for understanding life. But a pronounced sense of estrangement and fear during the period around 1930 prepared the ground for the formation of new myths, a process that in a certain sense we find repeated today. The historical study of myths acquired a definite antimodern and fundamentalist bias, while the study of late-antique gnosticism took a turn toward existentialism.[4]

The interpretations of myth offered by Freud and Jung offered another alternative, one from which the Surrealists profited. Myth, whatever the source of its constituent elements, became a common theme of the moment, in which context Beckmann pursued his own distinct path.

Hans Blumenberg's recent study of myth, *Arbeit am Mythos*, demonstrates how, in the modern period, research on myth became itself myth.[5] The icon of myth offers images of being that exist outside time and space, images that appear more significant than so-called reality. They are visual narratives that contain archaic truth and seem not to be invented. These archaic images still offer themselves once again for every search for the elementary content of human life. According to Freud, they tap an urge that everyone recognizes, for he feels this urge in himself.[6]

Studies on the nature of myth done in Frankfurt in the twenties arrived at results that must have pleased Beckmann. In his 1928 book *Die Götter Griechenlands*, W. F. Otto takes issue with the ethnological

27. DEPARTURE
1932, 1933–1935, New York, The Museum of Modern Art (Göpel 412), side panels: 215.3×99.7 cm., center panel: 215.3×115.2 cm.

and philological interpretations of Greek myths current at the time, complaining that they blindly followed mechanistic or literary interpretative patterns. According to Otto, it is beyond the time of the Olympian gods that we can catch a glimpse of true myth, that is, the "old religion," which tells us the mysteries of creation and death.[7] Otto's ontology opposes any relativism. It holds to the Romantic position that primeval belief reappears time and again under ever new guises and names. Thus myth transports man directly into the pulsing heart of the world, and so into the precinct of the sacred. In the timeless primeval thinking of myth, everything is born of experience.[8] In his 1933 book *Dionysos*, Otto compares myth with the artist. The artist also brings salvation to all who are touched by his works, with the picture that gives expression to the spirit of a great destiny.[9] In the face of primeval phenomena, for which psychology and logic prove powerless, Otto repudiates the rationalism of science. Only from the being of the world itself can we derive wisdom, and so the greatest spirits who have peered most profoundly into the depth of the world must become our authorized leaders.[10] Such notions are closely related to Heidegger's doctrine of being and eternal values.

Beckmann's knowledge of myth derives from numerous and sometimes coincidental sources, the body of which other commentators have already reconstructed. The source line stretches from Schopenhauer to Flaubert's *Temptation of Saint Anthony*. Among the artist's early readings we find included such diverse texts as I. Donelly's *Atlantis: The World Before the Flood* and K. E. Neumann's *Sayings of Gautama Buddha*. Beginning in 1925, Beckmann immersed himself, though with occasional outbreaks of bad temper, in the almost unreadable four-volume *Esoteric Teachings* of the theosophist Helena Petrovna Blavatsky, a work in which all myths are compiled into a single antimodern sectarian textual compendium useful as a vademecum for any and every attempt to escape history.[11] But the sources of Beckmann's thinking are not as important as the patterns of thought they suggest. The most important element here is Beckmann's interest in the redemptive teachings of gnosis, which confirmed his belief in dualism, the division of the world into good and evil.

W. F. Otto distinguishes the "soul myth" of gnosis from the "world myth."[12] According to the tenets of gnosis (and to those of its heir, theosophical mysticism), human nature had gone wrong and became entangled in a destiny over which other powers had command. The original unity was broken once man began to search his soul and dream of its redemption from the constraints of the world. In Schopenhauer's work, Beckmann had first read of the gnostic cosmogonies, in which evil demiurges, warped creative forces, had delivered man into

a false world.[13] As Blumenberg has defined it, dualistic patterns that invite modern remythification are rooted in the return of the "ever same." He observes the repetition of the ever same story in which good and evil hold equal sway. The conflict between the two forces is seen as defining the cycle of the world. Decisions were made *for* man but not *by* him. If, in the wake of the old myth, things have never changed and have always been so bad for mankind, then periods of change tend to be accompanied by a hunger for new myths. But nothing in fact supports man's cherished conviction that the world has always been as it now promises or threatens to become.[14] These comments by Blumenberg in 1981 shed some light on the cultural climate of the years around 1930, when there was such a heated concern over the nature of myths; they also shed light on Beckmann's personal stance, the pessimistic thrust of which is evident in countless remarks.

Other voices likewise illuminate this particular cultural horizon: for instance, T. Preuss's *Der religiöse Gehalt der Mythen* (1933) and H. Jonas's *Gnosis und spätantiker Geist* (1934). We are not concerned here with a direct influence on Beckmann's thought, but want rather to establish the contemporary context to bring out the temporal specificity of Beckmann's own position. In his introduction to Jonas's book, the theologian Rudolf Bultmann praised him for having shed light on the mystery of gnosis by means of the analysis of human existence.[15] Jonas illustrated a fundamental concept in life evident in gnosis with Heidegger's untranslatable term *Geworfenheit*, which in the latter's *Sein und Zeit* means something like "the state of being hurled into existence."[16] In Heidegger's view, as paraphrased by Jonas, the world is alien to man for the very reason that man did not choose it and that it stands in the way of his true experience of being. The world, according to Jonas, is merely a dwelling place in which the soul experiences homesickness for the "elsewhere," that great beyond from which it comes. The notion of the "other life" for gnosticism is central to the elementary experience of alienation and transcendence. The space of the world, the very space in which life finds itself, is a demonic presence, and the demons are just as much personal as spatial entities.[17] Space and time must be traversed by the soul. Jonas's views on gnosis were remarkably close to Beckmann's philosophy of existence and art.

When Carl Einstein spoke of the reappearance of myth in art (see p. 55), he was referring not to Beckmann, but rather to the Surrealists. In Einstein's view, the psychographic art of the Surrealists reproduces dreams of the soul in which the mythic element still exists.[18] This is no archaic revelation but rather the anarchic structure of the unconscious, in which conventional logic has been suspended. The modern

tenets of Freud had a key influence here, together with the conceptual ramifications of the destruction of the classic notions of art as adopted from Dada. The result was an aesthetic anarchism. According the Einstein, the old powers of the individual were reemerging in an altogether different form. Now they would follow the automatism of the soul. As a result, the artistic depiction of myth could no longer be figural in the usual sense. The work of the Surrealists was proof of his point. Man, Einstein continues, is no longer bound to a commonality of vision. The very nature of life, that is, the world itself, is fragmented. Only free association can still break through the internal experience of the personal, facilitating communication with the external common experience. Such free associations arise out of "instant writing"; Einstein refers to André Breton's *écriture automatique*.[19] The world can no longer be depicted as such but can be alluded to only by means of primitive signs and symbols that come from the unconscious. Even those Surrealist paintings that appear to be figural, as for instance *Arcadian Landscape* (1935) by the Belgian artist Carel Willink and *Expectation* (1936) by the German painter Richard Oelze, are, as landscapes, merely formulae for the interstitial space of the soul, in which only utopias and obsessions can be expressed.[20]

Beckmann opposes the Surrealists with an alternative concept of art, the roots of which he seeks in the tradition of art, and bases his conception on a kind of artistic metaphysics. The unconscious is for him the matrix of the creative genius, his soul, which offers access to a deeper level of being. Myth for Beckmann is the riddle of an elementary order buried in the rubble of modernity. The contemporary world is too modern for him, whereas it is not modern enough for the Surrealists. He dreams of discovering a utopian world for the sake of and by means of art. The distance between Beckmann's and the Surrealists' dream worlds proves to be a rather unbridgeable gap. Freudian notions set the Surrealists apart. Yet Beckmann's experience is equally modern. His artistic response, however, insists on a recollection of an archaic existence, in which he seeks salvation from his hopeless subjectivity. His figurative art, whose standing he stubbornly defends, takes on a surprising aspect when viewed in light of this conflict. It is a kind of guarantee for his belief in an objective order of being, which cannot be dissolved in a mere subjective consciousness. Figurative art, at least in the cultural milieu of his day, proves to have been a conservative undertaking—not in the sense of a retrogressive clinging to old forms but in the sense of a symbol of a time-honored world view. The fact that in the thirties Beckmann acquired false partisans among the Nazi painters made his artistic struggle all the more dramatic.

28. THE RAPE OF EUROPA
*watercolor and graphite,
1933, Private collection
51.1 × 69.9 cm.*

In paintings like *Man and Woman* (fig. 10), he came very close to
Surrealism. The discontinuous space and the idiosyncratic plant sym-
bols give this impression. Yet the painting is not the result of free
associations but is rather the vision of a cohesive whole, in which one
is even given to suspect the presence of that which is not visible, a
glimpse beyond the "mythic edge of the world," to borrow a notion from
Blumenberg. In the big watercolor *The Rape of Europa* (1933; fig. 28),
Beckmann reacts in a still more decisive manner to the mythic theme
of the Surrealists, now possibly seen through the lens of Picasso's
work.[21] On June 1, 1933, the first issue of the magazine *Minotaure*
was published, for the frontispiece of which Picasso conceived the now
famous collage. A month later, Picasso produced his drawing *Baccha-
nal with Minotaur*.[22] The connections with Beckmann's work still re-
quire a closer examination. But the latter's counterposition is clear.
Beckmann takes the mythic theme literally and traces it back to na-
ture's power, but also to eros, by whose agency man is led astray
across the ocean. Also in 1933, W. F. Otto's book *Dionysos* appeared,

which traces the bull back to Dionysus and his dual nature.[23] A Greek relief in Berlin depicting the sacrifice of a bull offered the formal inspiration.[24] Beckmann presents the theme within a higher order. The playful element promoted by the Surrealists is missing. Beckmann, taking myth very seriously, gives it a personal interpretation and thereby keeps it alive.

In some paintings he reinterprets familiar myths; in others he invents new mythological themes conceived according to his own sense of myth in modern life. The watercolor *Odysseus and the Sirens* (1933; fig. 29) is an instance of the former;[25] paintings like *Journey on the Fish* (1934; fig. 34) or even *The Catfish* (1929) are instances of the latter.[26] *Man and Woman* (1932) stands somewhere in between, since it has associations taken only from mythic tales. Odysseus, the wanderer lost on his misdirected journeys (depicted also in the painting *Odysseus and Calypso*, 1943), is not only the protagonist of a gnostic philosophy but also a role representation of Beckmann himself.[27] From the early thirties on, mythological themes dominate Beckmann's work. He now has so much self-confidence as an artist that he allows himself to represent such themes in versions accessible to everyone. The very purpose of his art after all is to find a vehicle for preserving the meaning of myth in a modern artistic form. In this sense too his works are tightly bound to a great tradition.

There are contradictions here that cannot be resolved even by recourse to a hidden dualism, however. The mythic creed cannot be brought into accord with modernity unless it promises a way out of the modern condition. One could retitle Beckmann's first triptych, *Departure* (fig. 27), "A Way Out."[28] The painting is built around the antithesis of the wings and the central panel. The tormented world depicted in the wings remains rooted in the closed space of the modern consciousness and presents an inventory of nightmare visions similar to those of *The Dream* (1921) and *Galleria Umberto* (1925).[29] Beckmann's "modern man" is here entwined in the self-engendered images and reflections of his own consciousness. Yet in the central panel the depicted space opens up into an unlimited distance, and mythic figures give the signal for a new beginning or a return home. It appears as if this myth were intended to be read literally. But it is the power of the painting that alone produces this impression, for there is no actual narrative as such. The positioning of the myth in the framework of the three-paneled painting elaborates its allegorical place in the world. It suggests a way out of the labyrinth of modern consciousness (*sortie* is a key word that appears in many of Beckmann's paintings). Yet the painting can only allude to, and never specify, the exact

29. ODYSSEUS AND THE SIRENS

watercolor, 1933, New York, Private collection 101 × 68 cm.

nature of this promised escape. It could be death, in the sense that death promises salvation into a higher form of being. The vision across the sea as granted to the beholder serves as a symbol for the experience of transcendence. In this we come very close to the essence of Beckmann's mythic creed. "In place" and "right" are terms he uses for ideals that reconcile him with his painful existence.

The presence of myth, however much it becomes visible and tangible in Beckmann's oeuvre, cannot be verified in terms of any definite programmatic statement. It is, in terms borrowed again from Blumenberg, no "fundamental myth," but rather an "art myth."[30] It transcends the narrow circle of subjective and personal inventions only when the viewer, in order to commune with Beckmann, makes the effort to rediscover his own dreams in the paintings. Only when Beckmann's art strikes a responsive chord in the viewer's metaphysical being is that art redeemed from mere subjectivity and lifted to a higher level of truth. This is why the viewer's comprehension is an essential test for the promise of this art, and why the artist cannot seek to explain verbally that which can be perceived only visually. The proof, finally, is entirely with the power of Beckmann's art. By becoming the sole possible language with which to express myth, art itself becomes myth.

6 BECKMANN'S NARRATOR-SELF

The split between the individual and the world is the essence of the drama Beckmann paints. His individual is infused with a modern consciousness, and as Beckmann writes in 1936, he can accept the world only as a source of conflict.[1] The world is perceived in the mirror of the individual's own fictions and obsessions. This modern self has more parallels in literature than it does in painting. It corresponds to the narrator self of the modern novel (see p. 83), a literary form marked by the closure of its subjectivity. The narrator no longer makes his appearance here as the hero, the key protagonist of the tale, nor is he, in a direct sense, the speaker who comments on the tale. But the narrative thread is always infused with his point of view. He can suspend the split between the world and his subjective vision of it only by reflecting on the world.[2] Beckmann adopts the pose of self-affirmation, which he calls law of balance.[3] He sees the world as theater: the various roles have been assigned, the play keeps repeating itself. It is not Beckmann's play, but it *becomes* his when he depicts it from his point of view. Paradoxically, it is precisely when he perceives himself playing the narrator that, through reflection and distance, he is able to bridge the gap separating him from what he sees.

To this end, Beckmann must tap another dimension of himself, a loftier identity. The source of this new identity is not, however, a general experience of the world, but rather his personal belief in the existence of an alternative world. We may call this other dimension of Beckmann's identity his superself or transcendent self. Beckmann calls it "soul" and distinguishes between soul and self, referring to the former as the true self (see p. 94). In his view, the soul is not a fait accompli but an entity that evolves in the course of a lifetime through a process of clarification. Thus the narrator self is divided. It contains a second self alienated from the world. Through his art, Beckmann

seeks to make that second self transparent and thus perceptible. Since the thirties this concept had become a part of his metaphysical world view. According to theosophy, the soul, the indissoluble core of the person, comes into its true state of being through a series of rebirths and a process of purification. Several myths are metaphors for this process. The modern experience of the world, indeed any and all experience of the world, is but a transitory test for things to come. The transcendent self is a redemptive metaphor and therefore a metaphysical compensation for the modern self. It likewise possesses the transcendent aura of the creative genius, which is how Beckmann perceives himself. As such, it rises above the confines of strictly aesthetic expression into a deeper arena of truth, precisely in the sense of art as myth.

In his later works, the artist Beckmann speaks with two voices simultaneously. This makes the analysis of his work all the more difficult, for the work treats two disparate worlds accessible to either the one or the other self. Though they differ, the voices of the two selves often speak in unison. Neither has the upper hand. If the modern self were to dominate, then the world it encounters would remain nothing more than its own mirror. If the transcendent self had the upper hand, the world would dissolve in another mirror, that of the mythic background. Beckmann is able to speak with bitter irony of the world around him, and at the same time with ecstatic language of another reality, for which, however, he must find followers or like-minded souls able to grasp his meaning. This dichotomy runs through many of his works. Invariably it requires a decision on the part of the viewer as to how far he is willing to follow. The internal images, for which no realism suffices, are bound to the concept of "artistic metaphysics." They are produced by the will to transcendence. Art takes on the Nietzschean sense of a melding of these inner images, a prefiguring of a reconstituted unity.[4]

Approaches to the interpretation of Beckmann's narrator self can be found only among art critics who wrote on him prior to 1930. They are a point of departure for my own interpretative efforts. As early as 1923, in Paul Westheim's discussion of contemporary art *Für und wider: Kritische Anmerkungen zur Kunst der Gegenwart*, we find prophetic words. Westheim remarked that Beckmann takes umbrage at the world and uses every opportunity to show the world its sinister side. Beckmann is subjective. "That is the catchword: his art is 'self-art.' The way *I* see it, that is the way *I* mean it, the way *I* see through your whole little charade."[5] In Beckmann's paintings "the man always steps

in front of his work . . . the man with his thick-skulled self-assurance
. . . as he loves to slip into his own compositions." On the other hand,
altogether unlike Grosz, he always tries to bring out the metaphysical
and romantic aspect of things. He has the nature of a Lord Byron, for
whom the split down the middle of the world cut right through his
heart. His keenly premeditated brutality is essentially disguised senti-
ment.[6]

In the volume that Piper Verlag issued on Beckmann in 1924, Julius
Meier-Gräfe likewise observed that the artist seeks to renew meta-
physics for contemporary use.[7] What he means is Beckmann's sense
of the modern situation as metaphor, and not the artist's path toward
a metaphysical world view, which Beckmann evolved only later on.
In the same volume, Curt Glaser refers to Beckmann's art as proof of
a one-sided philosophy. He noted that it seems to be the fate of German
art to engender combative works and to indulge in problematic
issues.[8] This distinguishes German art from the noncombative pure
existence of things in French or Italian art. And in 1930 Otto Fischer
reduced the implications of the literary profile of Beckmann's "self-art"
to an aberrant German phenomenon. German painters, Fischer main-
tained, "do not create out of a love of the emanations of the world, but
rather out of the craving for knowledge, indeed out of the suffering
that leads to knowing." It is the inflicted rift between the self and the
world that they exorcise in their works. Their artistic creation is a
battle with the things they depict. It is the will to depict that establishes
the appearance of things. "The personal element becomes the only valid
element, the suffered rift and the consequent tension are presented
again and again as the true image of the world."[9]

Carl Einstein, the last in this sequence to express his view on Beck-
mann, remarked in 1931 that Beckmann's work gave visual form to a
drama. "It transforms nature into painting and uses its motif for an
invented vision. Thus the tension between motif and painted image
becomes a conscious element." Beckmann, according to Einstein, at-
tempts "not to avoid the conflict between preconceived attitude and
motif, but rather to deepen that conflict into an almost tragic confron-
tation." He wants to maintain his superiority in relation to the motif.
The work reveals the "as yet unresolved conflict of a man whose spiritu-
ality is perhaps more significant than the painstakingly painted re-
sult."[10]

The overall consonance of these views is surprising. And yet they
sum up a little too one-sidedly what they ascertain is a German idio-
syncrasy or a consequence of Beckmann's own personal conflict. While
the issue is sharply delineated in Beckmann's painting, it has more

far-reaching implications and cannot be understood as a uniquely German phenomenon. The "self-art" rooted in the split between person and world, which forms or deforms the world according to personal visions based on preconceived attitudes, is widespread in modern art and literature. In regard to painting, critics have tended to shy away from this theme, for fear of afflicting visual art with the stigma of the literary, which always appears to restrict the autonomy of painting. Dada and Surrealism are the only exceptions and are allowed a literary profile.

Art criticism thus lacks the categories to do justice to the "authorial" dimension of visual art. The author of a text is ascribed a role different from that of the painter. The former is allowed to tell of himself. The latter is supposed to restrict himself to depicting the world. It is all too obvious that the painter depicts the world as a literary author does: broken up into impressions and reflected against the mirror of consciousness. But no tradition of pictorial description lends credence to this truism. We tend to confuse the subject of literary authority with literary motif or a strictly literary issue in the most limited sense, that is, in those cases in which a painting merely retells a literary tale. Thus Beckmann the literary painter, whose paintings can by no means be reduced to their contents, still awaits discovery, and with him a whole segment of modern art history. It seemed to be a way out to analyze Beckmann's personal role in his paintings and painted subjects. This, however, is only a further consequence of the notion of "self-art." Beckmann indeed often introduces himself and his life situation, for instance in the self-portraits and the family scenes, or in those paintings in which he appears as actor, director, or circus ringmaster. The voluminous body of self-portraits indicates to what extent Beckmann mirrors his own life in his art. Even in themes of a not strictly biographical nature, he suddenly appears as a clown or a minor member of the cast.

And in fact in those works where he himself does not make an appearance, he is always present, namely in the way things are perceived, the artistic standpoint that always bears his unique stamp. For Beckmann, the depiction of the world is always simultaneously a function of reflection, even when he is painting merely a still life. This aggressively self-imposed presence of the painter in his paintings impels critics to choose between an impassioned approval and an equally ardent rejection of Beckmann and his work. The situation somehow resembles that of reacting to personal opinions that can be only confirmed or contradicted. And contradiction translates as outright rejection when it comes to a painting, since a painting cannot be contradicted. The canvas may disappoint the viewer's expectations.

The disgruntled viewer then responds by rejecting the work out of hand. In those cases in which the personal component is such a pivotal part of the viewer's response, the painting's claim for a general truth appears to be limited. But at the same time if the work is clearly recognized as a private vision, the viewer is also more likely to grant the painter free rein. Beckmann often throws his viewer off guard and confuses him by a synthesis of objective and subjective visions. He thereby forces the viewer to compare his own experience with Beckmann's interpretation of the world.

Stephan Lackner took a first step toward a clear understanding of Beckmann's literary self-art in his essay "Das Welttheater des Malers Max Beckmann," written in 1938.[11] The theater or the circus metaphor has been a virtual sine qua non of Beckmann scholarship ever since. Its relevance became evident as soon as the affinities between Beckmann's triptychs and the theater had been confirmed. More recently, Claude Gandelman explored in depth the analogies with the multitiered stage structure of the Expressionist theater.[12] An analysis of the triptych paved the way for an appreciation of Beckmann's early use of stage situations, complete with curtain and actors (see p. 29), and his occasional perception of the painting itself as a stage. The canvas functioned as a stage for him even in paintings in which a play is not the overt subject. And when presenting himself, Beckmann creates a painted stage to frame his appearance. The stage setting is a metaphor for the literary reflection inserted by the painter between the viewer and the depicted world. On this stage, the author or director Beckmann has the first and last word. As he said in "On My Painting," he permitted his figures to come and go on this stage, interpreting them in such a way that they seem comprehensible to him.[13] They are the creatures and projections of the author's imagination, produced by his consciousness. We can use this theater metaphor as a point of departure for a consideration of Beckmann's literary narrator self.

Marianne Kesting's book of literary criticism *Entdeckung und Destruktion* points us in the right direction. Speaking about Joyce, Brecht, and Beckett, Kesting perceives in the modern novel the shift from action to reflection. The action here is not factual narration after the fact, but rather the freely selected narrative material of a subjective consciousness.[14] To the social loss of individuality the novelist replies with extreme subjectivity. He presents as a utopia precisely what society withholds from the modern individual. As an antidote to alienation, he offers the closed identity shared by author, novel, and reader. In applying this argument to Beckmann, one might say that the aesthetic middle ground of his canvases encloses the painter, the painting, and

the viewer in a single space. And in so doing, the painting initiates a dialogue in which more true things are said about the real world than in the real world. In Beckett's words, the artist creates his own "*univers à part*," a world unto itself, so as to be able to make sense of it all and satisfy the need for order. And where in the modern novel the hero as actor is missing, the disguised author takes his place. The author projects himself into the lacuna left by the lost epic distance. His consciousness dictates time and space. He maintains control over the projections of his own self.[15]

A consequence of this phenomenon that Kesting describes was the invention of an autonomous literary language. It was as much separated from everyday speech as the self is from its surroundings, and was, according to Rimbaud, intended to express the inexpressible. In Mallarmé's utopian vision of language (just as later in Kandinsky's abstraction and Malevich's suprematism), the autonomous language (or autonomous realm of form) is more real than the so-called reality. This shifts the accent from life itself to the self-reflective life of art. Absolute poetry is the opposite pole of the emptiness experienced in the world. To combat emptiness, art engenders an aesthetic universe. Abstract art likewise replaces the lost sense of a real world by creating an alternative world.[16]

Beckmann clearly followed a different path, unjustly branding abstract art as mere decoration. He sought the source of his artistic reflections in the world around him. Transcendence for him means transcendence of the world. It demands the existence of a real world in opposition to which Beckmann can experience conflict. His consciousness is the mirror of the world he depicts, just as art is then the mirror of his consciousness. Both his consciousness and the art that emerged from it are double mirrors. The modern self finds its mirror image within the world, and from the opposite side the transcendent self mirrors itself in the depth of a world beyond. Often Beckmann expresses this hidden dualism by presenting the painted space of the canvas as the mirror of the world and by including a mirror as a separate motif: this painted mirror captures a reflection of a reality extraneous to the subject of the painting. In this way the viewer is seduced into following the "author" into another reality. Yet the fulcrum of the process is firmly rooted in the empirical world. Without the world around him, the personal perspective so vital to Beckmann would have no point of departure.

The modern self can also be described as the role-playing self, as it assumes an assortment of roles in the world. In representing himself,

Beckmann adopts the roles of clown, magician, actor, or circus ring-master. This facilitates distance, but in the defiance, irony, or sadness of the depiction, it also serves as a vehicle of self-expression in opposition to the role. The roles change, the self remains the same. It grows more and more substantial in each successive work, whereas the roles grow ever more transparent. The artist's inner world is elaborated. The role-playing self is the role adopted by the worldly self. In slipping out of its role, then, the self confirms its extrinsic existence. It can express itself in the world only through the roles it adopts. It transcends these roles precisely by switching from one to another. Even the many self-portraits are masks that record the roles in the phases of Beckmann's life.

The role of circus ringmaster symbolizes Beckmann's artistry. It is no coincidence that Beckmann also wrote plays. In his painted dramas, he himself makes frequent appearances. The script Beckmann holds in *In the Circus Wagon* (1940; fig. 30) clarifies the meaning of the painting.[17] Here he is the director and as such the counterpart of the

30. IN THE CIRCUS WAGON
1940, Frankfurt,
Städtische Galerie im
Städelschen Kunstinstitut
(Göpel 552)
86.5 × 118.5 cm.

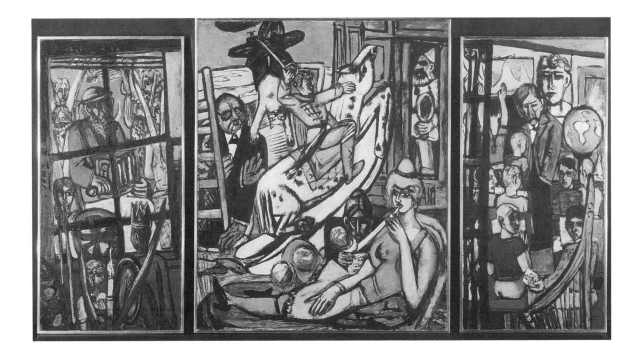

31. THE BEGINNING

1946–1949, New York,
The Metropolitan Museum
of Art (Göpel 789) side
panels: 165 × 85 cm.
center panel:
175 × 150 cm.

modern literary author. Other figures—the animal trainer, the midget clown, the dancing girl—are performing his play. They do not act in unison, indeed do not even appear to be aware of each other's existence. The circus ringmaster is depicted reading them their parts in the play he has prepared for them. They are fictional emanations of his narrator self, which instructs them when to enter and when to exit. The script contains the text of a play that in fact deals with the author alone. The painted story is an explanation of the world which Beckmann gives himself.

On a bed at the center of the painting, surrounded by the other figures, the dancing girl reclines in an enticing pose, with a playing card in her hand. The crippled man, whose lantern sheds light on her, can only look on from afar. The animal tamer, wearing a dark expression and wielding a whip in his hand, keeps watch over a cage of wild animals. An acrobat climbs a ladder in an attempt to escape the prison of depicted space. It is not only in this latter motif that Beckmann takes up again the tenor of the 1921 painting *The Dream.* Now the painting has acquired the precisely calculated shape of a stage, and the viewer witnesses a play whose structure is laid bare before him. The painter has gained more distance from his theme, the theme of life.

In his self-portraits, Beckmann assigns the role that the artist plays, refrains from playing, or has yet to play in society. *Self-Portrait in*

Tuxedo (1927; fig. 24) is the dress rehearsal for a utopian role (see p. 59). *Self-Portrait with Horn* (1938; fig. 26) is the return to a role at the periphery of society (see p. 62). Biographical elements are apparent in *The Liberated One* (1937), from whose title figure the shackles of the Nazi regime fall. In the triptych *The Beginning* (1949; fig. 31) Beckmann returns to the initial steps of his role-playing.[18] The nursery with the rocking horse and Puss-in-Boots and the classroom beside it are painted autobiographical allusions, the roots of roles to come. In the sky visible through the window at which the little stargazer sits peering out, we see the organ grinder/God the Father with his shaggy beard, the first childish version of myth in Beckmann's experience. Beckmann hearkens back to a biographical instance in the life of his artistic role model, William Blake, who at age four saw God's face peering in through a window and broke out in cries of terror. Thus Beckmann sees himself as a spiritual and artistic heir to the English mystic (see p. 69).

The roles become more defined in a biographical sense in those paintings in which the role-playing is divided up between two or more actors. In the double portraits that depict Beckmann and his wife, the artist is able to circumscribe not only the subject of the relation between the sexes but also his own life situation. In artistic quality and number, the double portraits come just after the self-portraits in Beckmann's opus. In the wake of World War I, they were replaced by family portraits, in which his son and his wife's family also have parts to play and help define Beckmann's depiction of himself. The double portraits of 1925 indicate a change in the artist's life. Beckmann himself takes on a different role in the Mannheim *Carnival* (fig. 32)[19] from that in the Düsseldorf *Double-Portrait Carnival* (fig. 33), done in the summer of 1925, only half a year later.[20] The two paintings, which have the same format, are related to each other like question and answer, problem and solution, and are also thematically akin in that both treat the subject of the carnival. They confirm the "law of reprise," as I would like to call Beckmann's frequent procedure of executing a second version of a painting in order to actualize a potential latent in the first, and so replace it.

The first painting cited above is a double portrait masquerading as an allegory of Pierrette and the clown. The woman is both an embodiment of and a buffer against the seductive charm she holds for him. The half-threatening, half-comic clown, his legs stretched out and up, is ignored by the woman and has his face covered. The biographical situation, Beckmann's courting of Mathilde von Kaulbach, nicknamed Quappi, is obviously the stimulus for this characterization. The second

32. CARNIVAL

1925, Mannheim,
Kunsthalle (Göpel 236)
160 × 100 cm.

painting referred to above was done later, shortly before their wedding. The roles are reversed, with the man, decked out as Watteau's proto-typical Gilles, now leading the way. The couple has just stepped out from behind the stage curtain and are being announced. The focus of attention here is not the private relationship between the man and woman, but rather their external relationship as a couple to society.

The important paintings that deal with the relation between the sexes take the place of the double portraits around 1930, and also serve to introduce Beckmann's role as spouse and man in general. In a letter the artist wrote to Stephan Lackner in 1939, he calls the creative man "that boundlessly versatile actor" whose task it is to represent his life situation of the moment. The narrator self asserts this notion in many literary formulae, which were in fact borrowed from mythology. *The*

33. DOUBLE-PORTRAIT CARNIVAL

1925, Düsseldorf, Kunstmuseum (Göpel 240) 160 × 105.5 cm.

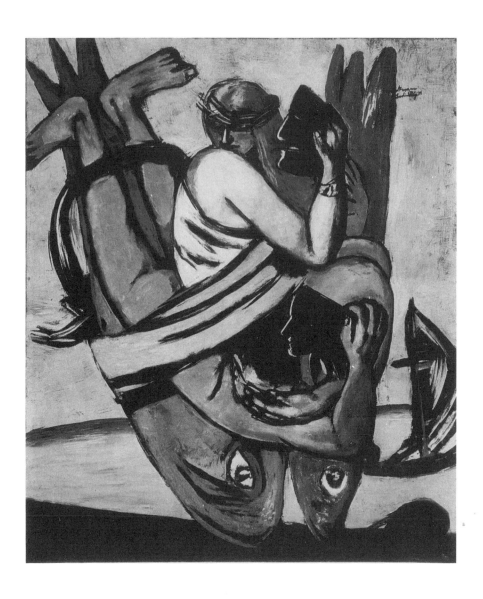

34. JOURNEY ON THE FISH
1934, USA, Private
collection (Göpel 403)
134.5 × 115.5 cm.

Bath (1930), enacted in a private milieu, reduces the couple's relation-
ship to that of antithesis, in the depiction of which the woman, who
is in the act of undressing, takes on a downright startling dominance:
she is the personification of seduction.[21] The antithesis is even more
pronounced in *Man and Woman* (1932; fig. 13), albeit in a different
sense.[22] The couple's relationship symbolizes the opposition between
the interior and transcendent world in such a way as to transpose it to
the level of universal myth (see p. 29). In *Journey on the Fish* (1934;
fig. 34), the man and woman are shackled to one another.[23] Each holds
the mask of the other: the mask of the man clearly bears Beckmann's
profile.

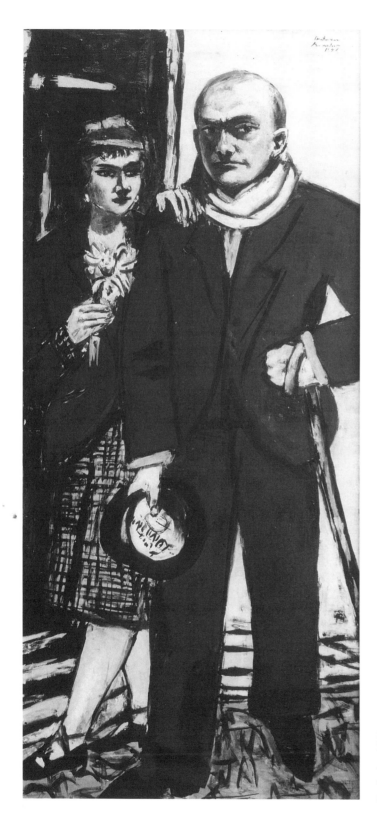

35. DOUBLE-PORTRAIT, MAX
BECKMANN AND QUAPPI

1941, Amsterdam,
Stedelijk Museum
(Göpel 564)194×89 cm.

In the autumn and winter of 1940–1941, while exiled in Amsterdam, Beckmann worked on the monumental *Double Portrait of Max Beckmann and Quappi* (fig. 35).[24] Decked out in fine clothes, the two step out together as though both wished to depart on a perilous journey into the world. Their roles are as subtly distinct from each other as they are related. The man, who appears both powerful and strangely fragile, shelters the woman behind him with his body. Stretching both her gaze and her hand out toward him, the woman appears, however, to lead the way, while the man's gaze is directed out at the world. The dark brown of his suit and her jacket binds them together, yet the background—light yellow behind the man and dark behind the woman—separates them. Like Eve in *Man and Woman*, the woman holds a flower as if it were a treasure. The man grasps his walking stick and hat like weapons. With its overt simplicity this painting is in fact surprisingly complex.

The reference to *Double-Portrait Carnival* of 1925 (fig. 33) is evident. Not only does the same couple appear, but even their appearance resembles that early stage situation, in the woman's stride and pivot. Yet here the stage has been abandoned. The costumes from Carnival—or shall we say, from commedia dell'arte—have been given up. Nevertheless, though wearing ordinary clothes, the figures in this depiction of everyday life seem costumed. Beckmann's most important role, that of playing his own life, comes to the fore where all other roles have been exhausted. Even his civic role is one whose dramatic development was prescribed by others, particularly at the beginning of World War II, and in it Beckmann wanders as a stranger through the world. In the later double portrait, the clothes seem a disguise. The role separates itself from the self; life itself is a role. By the time he completed this painting, Beckmann had already come a long distance in the play of his life. On December 18, 1940, while still at work on the painting, he recorded in his diary: "The role you're playing at the present moment is the most difficult and most magnificent that life could have offered you—don't forget this—Max Beckmann—precisely as it is." The next day he wrote: "[Worked] very well on the double portrait." He is referring to the aforementioned painting.[25] In 1947 the emigrant Beckmann left Holland and accepted an invitation to teach at the Art School of Washington University in St. Louis. A photograph taken at the time shows him and his wife in evening attire, making an appearance at The St. Louis Art Museum (fig. 36). They are posing for the camera in front of the 1940 Amsterdam double portrait, which had traveled to St. Louis for the retrospective exhibition in 1948. Beckmann's profile casts a shadow on the painting, in the same manner

we find repeated in countless of his works. The photograph may have been Beckmann's idea. Since having painted the work before which he poses, he has moved on to a new episode in life; yet he still performs the role life has handed him: that of being Max Beckmann.

*36. Max and Quappi
Beckmann in St. Louis
1948*

If, however, even Max Beckmann is a mere role, then who is playing it? Behind the modern self, Beckmann's dualism postulates yet another instance of personhood. The transcendent self that Beckmann calls

"soul" evolves in the course of one's life, he maintains, on the inner path of self-realization and purification. His painting hints at it yet never depicts it explicitly. Only his textual remarks can help us approach his meaning. They too, however, remain cryptic.

In the 1938 lecture "On My Painting," the painter spoke of the search for one's own self, "for the self is the great veiled mystery of the world."[26] By this he does not mean simply the individual, the identity of the person. Nor is he referring to the self in its eternal and unchangeable form. Its path is in some strange and peculiar manner our path.[27] In the heart of the bitter pessimist, the mystic emerges. He seeks in his art the path to a higher reality—as Beckmann wrote in 1948 in "Letters to a Woman Painter"—or what amounts to the same, the way to the individuality of one's own soul.[28] In the 1938 lecture he referred to the soul as the unchanging core of strength, which empowers our spirit and senses to express personal things. Whatever we call that other pole of being, it is clearly distinct from the modern self and cannot be confused with any of its roles. For Beckmann, this conceptual safety zone is important because it offers a background for his art. Art should not merely depict our everyday life but also open it up to a secret only art can reveal. Thus Beckmann defends the aura of his painting, in "Letters to a Woman Painter," when he alludes to the transcendent self. The artistic and the metaphysical postulates become indistinguishable from one another. Perhaps, the artist maintains, "then we can find ourselves, see ourselves in the work of art. Because ultimately, all seeking and aspiration end in finding yourself, your real self, of which your present self is only a weak reflection."[29] Art, we must conclude from this, gives a hidden voice to that true self. And thus it becomes the dream of modern man.

Beckmann's words provide no recipe for deciphering the mystery of a single one of his paintings. This is not what they were meant to do. They are rather a spoken summons to the viewer to seek for himself the double-edged meaning of Beckmann's painting. If Beckmann makes an appearance playing historical and mythological roles (Faust, Mephistopheles, Pilate, Odysseus), he does so to invite the viewer not only to try out the role himself but also to perceive the world as a foreign place in which one can lose one's way. In the watercolor *Odysseus and the Sirens* (1933; fig. 29) and in the oil *Odysseus and Calypso* (1943), Odysseus the wanderer does not find his way back home in this world.[30] As a character, he is derived from the same mythic imagination that portrayed the world as a labyrinth in which the self is not at home. And since he can never find his home in its labyrinthine byways, his search for transcendence is both his inheritance and his

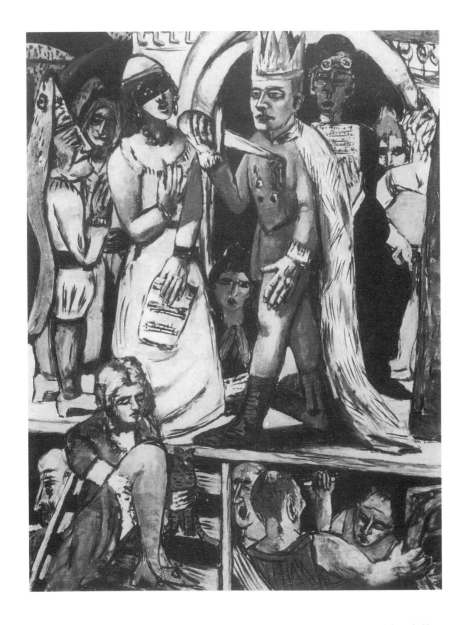

destiny. In this regard, Beckmann's Odysseus is distinctly different from Joyce's Ulysses. Beckmann owned the first German edition of *Ulysses*, published in 1927, and in a conversation with Reifenberg in 1929, he praised Joyce's realism.[31] But he did not let his Odysseus wander aimlessly through the interior space of his consciousness, as Joyce had done with Mr. Bloom, but rather created a goal for his interior journey of self-purification.

In the theater, which he selects repeatedly as a metaphor for his depiction of the world, Beckmann introduces more and more players who amble in from elsewhere. And the curtain behind the stage opens

37. ACTORS
1941–1942, Cambridge, Massachusetts, Fogg Art Museum (Göpel 604) center panel of triptych: 199.4 × 150 cm.

bit by bit to permit a glimpse of the background beyond the horizon of the real. A dualism becomes ever more pointed in the choice of motifs and pictorial tools. In the triptych *Actors* (1942; fig. 37) figures appear onstage who are not even rehearsing their parts, but instead discussing the rehearsal of the other players.[32] The tragic king, played by Beckmann himself, can no longer distinguish the play from life and concludes his performance by stabbing himself while the others are studying their parts. Beckmann succeeded here in introducing a very dense depiction precisely because the depicted situation does not allow for any simple resolution. Entrapment in the play of life permits only a fatal exit, a departure from the game. This proves, however, that the actors do not become one with their stage roles but are able to transcend them. For the obvious purpose of this perplexing play is to point out the split in the apparent immanence of life, and to reveal it as mere façade.

In the dream paintings, Beckmann justifies his dualistic perspective in a different way. In an early painting, *The Dream* (1921), his subject is the inner space of consciousness from which one can never emerge.[33] Blind or sleepwalking, the figures in the painting stagger about. In *The Organ Grinder* (1935; fig. 38), the dream scenario is taken up again and transcended.[34] To begin with, the figures depicted here, who have no contact with each other, are once again "dream emanations," projections of the consciousness that dreamed them up. At the same time, they are "types," each of which has its place in the metaphor of life. There is the organ grinder, who keeps playing the same tune on his hurdy-gurdy. Behind him are the same allusions to sexual organs relating to the battle between man and woman that are in *Man and Woman* (fig. 10). To the left and to the right stand a man and woman with big blue flowers: on the left an enticingly naked blonde, on the right the dreaming Harlequin with eyes blindfolded, who is peering inward into his "true self." Musical instruments and what seems to be a black canvas on the easel take up the foreground, paintings and a mirror form an allegory of art in the background. Behind the organ grinder stand two mysterious godheads: to the left a mother and child, and to the right an angel of death with bloodied sword, whose red and black coloring is thrown back at her by the mirror hanging on the right wall. According to Friedhelm Fischer, Beckmann had in mind a double portrait of the Indian goddess Kali, the deity who swallows up what she herself has brought forth.[35]

The antinomy of procreation and death is again encompassed in a metaphysical puzzle in two paintings of the same format, *Birth* (1937)

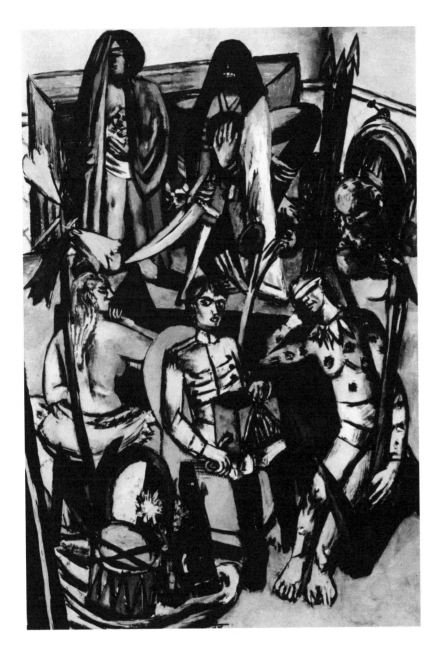

and *Death* (1938).[36] Did Beckmann merely look for black-and-white metaphors for the unity of the world, with that same unity reflected by the mirror, the same unity he elucidated in "On My Painting"?[37] Or did he wish to grant the viewer a glimpse beyond the mythic edge of the world, where an Indian myth represents the riddle of life? The dualism is made clear in *The Organ Grinder* by the two types of figures distributed in the foreground and the background. But it is not enough

38. THE ORGAN-GRINDER
1935, Cologne, Museum
Ludwig (Göpel 414)
175 × 120.5 cm.

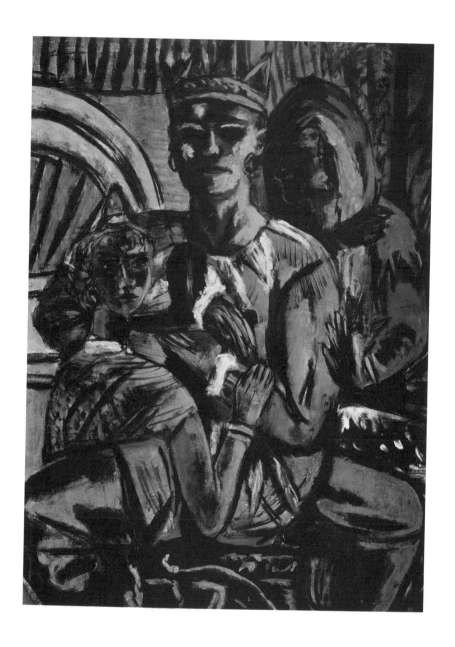

39. THE KING
1937, St. Louis, The St. Louis Art Museum
(Göpel 470)
135.5 × 100.5 cm.

merely to identify the iconographic repertoire, as though we were dealing with a Baroque emblematic painting. The place of myth and its connection to the transcendent self are only hinted at. The painter opens the door a crack, without, however, specifying what we might expect to see on the other side. The dream scenario is useful in understanding the painting. Beckmann also uses the motif of the dream to sum up thoughts in the lecture "On Painting." In his dream a figure from his paintings speaks to him as art and dream become one. In producing the painting, the artist experiences art as the single possible realization of his imaginative potential.

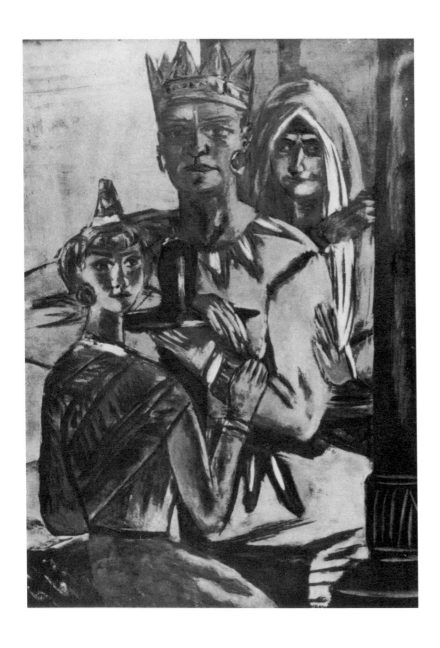

We can find no adequate formula to explain the geometry of the triangle of art-dream-transcendence. But the dualism embodied in Beckmann's narrator self can, in conclusion, be explicated by considering two versions of *The King*, a painting that sums up Beckmann's sense of what it means to be an artist. The final version of *The King* (fig. 39), now in The St. Louis Art Museum, is dated 1937.[38] An earlier version, done in 1933 (fig. 40), is preserved in a photograph taken at the time. The king portrayed in the two versions is both a theatrical king and an archaic ruler. Above all, of course, he is Max Beckmann. Since the painting claims more than it can fulfill, its contradictions

are covered up by a veil of light and color, behind which the riddles remain at a safe distance. Obviously the first version did not suffice, and was radically revised.

In the final version, the king's face has been darkened, so much that the eyes no longer meet the viewer. His torso has been shifted forward by means of the spread-legged seated motif of the dancer in the portrait of N. M. Zeretelli (1927). The king acquires more control over the painting and more freedom within it. The woman in the foreground holds onto him for protection, as in the earlier version, but now placed behind his leg, she no longer hinders his freedom of movement. The sword that he holds in his curiously crippled hands is no longer pointed at her. The other woman, who stands behind him, is turned so that we see her in profile, her face transformed into a black mask, hallmark of one of the two goddesses in the triptych *Temptation* (1937).[39] Perhaps the two women represent birth and death, eros and transcendence, powers that delimit the life of the king. A wheel has been added in the background, which Friedhelm Fischer has traced to Indian mythology.[40] It completes the hero's attributes. The king's robe, of a regal purple, is topped with a clown's collar. Even the crown and the earrings appear to be theatrical props. And yet the aura that surrounds the king is not from a theater milieu. It is above all the light that makes the colors and the gold sparkle, transforming the painting into an unreal vision. The king himself is divided into *chiaro* and *scuro*; this play of light and shadow is particularly dramatized in his face. The light strikes the depicted figures and makes them strangely transparent, as though they were lighted from within.

Who is this king? In *The Actor* (fig. 37) he is the tragic hero who mistakes the play for reality. In Beckmann's diary entry for January 19, 1943, we read: "Searching for a homeland, he lost his home on the way —this is how all truly great real-life kings come to die."[41] Such clues repeat themselves. They are only fragmentary hints at the mystery of life that the 1937 *King* seeks to depict.

The precise contours of the artist-monarch become clear if we consider a text by Gottfried Benn, published in 1935, that is, during the period between the two versions of Beckmann's painting. At times it seems almost like a description of the painting, and it may well have been one of the inspirations for the second version. Benn's text is revealing for those who, no longer familiar with the temporal horizon out of which the painted and poetic works emerged, need to know the context in which the two artists formulated their visions.

The text is a review of a book by J. Evola, which in German translation from the Italian original bears the telling title *Erhebung wider die*

moderne Welt (*Revolt Against the Modern World*).[42] In it a traditional world is evoked, displaying a fundamental opposition to history. "History has come to an end. The modern world is upon us," says Evola. The traditional world that ended even before the birth of Greek tragedy is presented as a vision of elitism, grandeur. Only the liberation from the shackles of history can bring the metaphysical stratum of life to the fore, a stratum in which the transcendent man still dominates. Evola concludes: "There are two orders, a physical and a metaphysical; two natures: a lower and a higher; the lower nature is rooted in becoming, the higher in being." Mythic man is pure, solitary, inescapable spirit. Benn concurs with Evola's view of life. Tradition, he maintains, was "the constructive principle of the throne of the sun, upon which the regal godheads sat at the center, the axis, the pivot of the wheel," as "beings of fire and light," directing its whirl. In the tradition world there was a real connection between spirit and reality. Ever since its collapse, Europe has sunk into emptiness.

Yet the transcendent has been lost. It was there that "the scepter-toting unity formed of ice and light" triumphed over the "life of realization." Greatness today is nothing but a matter of "memory, not action. . . . Thinking is suffering." The dualism has become heightened in the "final period," in this world dominated by the masses. A strange dark visage peers out of the lost tradition-world, over the edge of the real. It can be preserved in silence only by small aristocratic orders. Benn's emphatic commentary on Evola's book sheds light on a modern trauma, that a sense of the loss of reality is compensated for by an inner flight into a retrospectively applied utopian vision. In Benn's acute phrasing, the tone in which these metaphysical postulates are declaimed is hardly bearable. In Beckmann's painting, as in painting in general, the visual message never becomes quite so acute. And in any case, Beckmann is not Benn. Yet he too defended in a stentorian tone the sovereignty of his artistry against the slavery and collectivism of contemporary culture. His aversions were the same, his position also to uphold "style" in opposition to spiritual decay. We would be suppressing the truth if we failed to consider the spiritual tradition and the time that Benn's text so painfully illumines.

The destruction of art and humanity that took place in Germany after 1937 had a cleansing and sobering effect on a pose enthralled with its own pathos. But it also served to heighten the fears and awaken even more in Beckmann the longing for metaphysics. In addition, the painter had grown older, and come closer to death. As an artist, he had once again become famous, albeit not in the German milieu from which he remained alienated. Thus Beckmann the artist was no longer in need

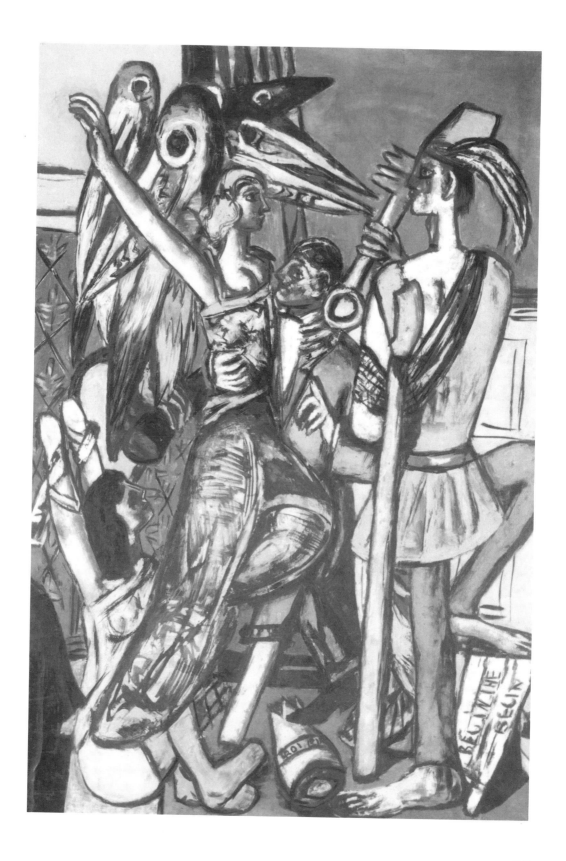

of a weapon to defend himself in the face of injury. In its place, however, the self-reflection of Beckmann the man became all the more dense, and its painted formulae more stark and simple. In the years after World War II, astounding paintings came into being, works in which Beckmann's narrator self transformed biographical situations into universal legend.

Begin the Beguine (1946; fig. 41) is a melancholy dance vision with a promise of redemption, a painted interpretation in "rapture serene" of Cole Porter's popular melody and melancholy lyrics.[43] Ironically, the inscription on the painting misspells the title of Porter's song as "Begin the Begin" and thus refers to the ambiguities of "the third start of my life," on which Beckmann remarked in his diaries.[44] There is a new beginning, but Beckmann feels his age. The essential elements in the painting are the dance and the enigmatic Hermes figure with the large key. In the midst of figures like the prostitute with the mutilated

42. CABINS
1948, Düsseldorf, Kunstsammlung Nordrhein-Westfalen (Göpel 770)
139.5×190 cm.

41. BEGIN THE BEGUINE
1946, Ann Arbor, The University of Michigan Museum of Art (Göpel 727)
178×121 cm.

arms and the male dancer with a wooden leg, the woman dancer uses her evening gown like a wing to free herself from all limitations. The figure of the inviting god holds the key that announces the beginning of a life of another kind. The text of Porter's song promises "rapture serene" as a memory of love and as a new effect of art which happens "when that tune clutches my heart." Thus Beckmann may well refer to the power of art to overcome the failures of life and to unite the lovers (the two ways of the self?) again. "And suddenly we know what heaven we're in, / When they begin the beguine." In "Letters to a Woman Painter," Beckmann says: "Art, love, and passion are very closely related because everything revolves around knowledge and the enjoyment of beauty." But he continues: "Self-will and passion, art and delusion are sinking down like a curtain of gray fog." For the time being, all we have to go on is art. "There are certain definite ideas that may be expressed only by art" (see p. 122).

The big painting *Cabins* (fig. 42), which dates from the interval between two sailings to the United States in 1948, may be understood as a painted counterpart to "Letters to a Woman Painter" from the same year.[45] Painting and life are related to each other in many ways. The young woman in the bottom right paints the boat of life, in whose cabins the single stages of the journey of life are located. We follow the sequence of love and passion, birth and grief as we look through the small grated cabin windows. The end of the journey comes into sight when a sailor ties the big fish, symbol not only of life but also of the eternal soul, to a flat board such as is commonly used for burials at sea. The double meaning is all too obvious. When reaching the water, the fish regains its original element and finds home.

Falling Man (fig. 43), completed in January 1950, hardly a year before Beckmann's death, is a painting that once again draws Beckmann's narrator self into the double mirroring of world and transcendence. An interpretation of the painting will serve to bring our argument to a close. On December 26, 1949, the painting had already been propped up on the easel a good month, when it went through a "final revision." "I think it's finally right," the painter wrote.[46] A mythically naked man fills almost the entire canvas with his mighty figure. He is tumbling head over heels into the abyss between two skyscrapers. The tall buildings are burning, flames shoot out of the windows; possibly they indicate the reason the man leaped. While falling, he scrapes the railing of a balcony which resembles a wheel: apparently he jumped from this balcony. His leap can lead only to his death. Yet lifeboats with strange sails pass across the sky into the canyon between the skyscrapers. White clouds cluster. Suddenly the man seems to be falling no longer

43. FALLING MAN

1950, New York, Private collection (Göpel 809) 142 × 89 cm. See p. 68.

104

downward, but upward into the blue sky, into another spatial dimension.

The spectacle of this painting is puzzling, its message contradictory. A single figure frozen in a single pose expresses an antithesis. Death and salvation are combined in one visual metaphor. The descent is escape as the modern self turns in its fall away from the world. The transcendent self finds its way back to its own world. The unity has thereby been severed. Beckmann, who in his *Falling Bicycle Rider* of 1913 had tapped the metaphor of the fall for its manifold significations, now recalls a passage in act 1 of Goethe's *Faust* (part 2), which he illustrated in 1942–1943 with 143 pen drawings.[47] Beckmann had invented the motif of the fall to depict Faust, who had taken Mepistopheles' key with him on his journey to the mothers. Mephistopheles interprets this journey as the path from becoming to being, when he calls to Faust: "Then sink! Or should I say: Rise!—it's all the same. Flee from the created world into the elysium of the free!"

The utopian vision in Beckmann's painting *Falling Man* emerges as the reverse of what the work actually says, or is perhaps a function of double negation: the dissolution of the dissolution of life. Thus the utopian message is a function of indirect speech or implicit meaning. There is no other way to express it in our modern time. Now, in the last year of the aging artist's life, death and redemption are joined by him through various combinations. The equally enticing and threatening *Columbine* (1950) presents the "exit," as the inscription in the painting reads, or death, as eros is the reverse of life.[48] The triptych *Argonauts* (1950) transposes the expectation of the last secret of life onto the stage of myth.[49] Orpheus, who stands ready for the emergence of the ancients from the bottom of the sea, appears like a mythic nude, the spiritual brother of the falling man. The fall of this modern Faust into and out of the skyscraper canyon of New York is first a redemption from the individuality of the self, and second the utopian vision of a spiritual return home. Transcendence is a crossing over. The goal is the autonomy of the true self, conceived of as the counterpart to the alienated self. The role-playing self of the modern consciousness finishes by freeing itself from all roles. Beckmann said that the only possible solution was the will to transcendence. Yet he added, with a side glance at the utopias of his time, that "there is no universal solution, only an individual salvation" (see p. 51).

This is the essence of Beckmann's world view. His tragic experience seeks a formula of redemption in Goethe's sense of a unity of the world. Benn came to a similar conclusion shortly before his death, writing in the diction of *Faust*: "We will not fall, we will rise."[50] The notion of "upward, downward" had played an important part in Benn's poetry

from early on.[51] As a young man, he transplanted "death into the sea's deep redemptive blue."[52] In a modern alteration of this early lyricism, Benn perceives death "perhaps as but a transition, perhaps the end, perhaps the gods, and perhaps the sea."[53] Of the "transformation of being," he says: "Yet if you sink all the way, you'll find the turning point."[54]

Beckmann's *Falling Man* in this sense represents the vision of the undivided existence of which Benn wrote.[55] *The King* was still a depiction of the apotheosis of pure spirit, the spirit that literally faced the world and set its sword between a posture of resistance and a declaration of autonomy. *Falling Man* is a metaphor for liberation. It refers to the dissolution of modern existence. The liberation need no longer be fought for but should be promised as a salvation on the way to transcendence.

Beckmann's painted messages have much in common with the verbal message of Benn's poetry. For the painter likewise expresses his own experience of the world and his lost ideals in poetic dream images to which he gives an artistic reality. In this, he lays claim to what Benn calls the "lyrical self" in the poem "Lyrisches Ich," written in 1928. The experience of a loss—a universal experience of this generation—is transformed into art that emerges as the last bastion against the onslaught of alienation. *Falling Man* is a swan song, not only in the context of Beckmann's oeuvre but also for an entire tradition of heroically inclined painting that Beckmann brought to an end. Other attempts to perpetuate the tradition lead in different directions. The whole concept of a great art of painted poetry in Beckmann's sense has been called into question, as the notion of the world as an intelligible allegory has all but disappeared.

44. Max Beckmann in his studio at 234 East 19th Street, New York, February 10, 1950 (Photo courtesy of The Carnegie Institute of Art, Pittsburgh)

EPILOGUE:
BECKMANN THE PAINTER

In this book I have wanted to avoid two common perceptions of Beckmann that in fact contradict each other: the view of Beckmann as a realist and the impression of him as an esoteric philosopher. The first interpretation tends to isolate the earlier works, from around 1920, as the only ones of significance. The other view prefers the work done after 1930. I believe that Beckmann never was a realist painter in the usual sense, but I insist equally that he was not an esoteric philosopher outside his painted oeuvre. Anything Beckmann had to say related first to the mystery of art and second to the mystery of his own self or what he called his true self.

He used a mythical imagery whose archetypes (the sea, the fish, candlelight, and so on) give a figural presence to what otherwise cannot be made visible within the narrow limits of our visual experience. The symbols that serve this purpose are both general enough to be understood by the beholder and personal enough to be understood as his own confession. Abstract art was as foreign to him as any kind of "realist art." "Mystery of reality" is the key term he used to express himself, but it is the opposite of our notion of reality. His notion encompasses both the surface reality of the world in which we live and the reality of our own emotional and spiritual experience. It is the latter that dictated what the painter's eye revealed to him. He could not separate visual reality from personal expression, the object viewed from the subject viewing. For him, there was no need to justify that dualism of the visible and the invisible or of the objective and the personal view. Instead this dualism is inherent to man's experience of the world.

Such a position had repercussions on the artist's creed. Figurative art became and remained an obvious choice. Mythical imagery was a

means to escape a simple naturalism and to enhance the deeper meaning of art, particularly in relation to photography or the fashionable social realism of the twenties, which existed also in the West. Personal and artistic tenets guided Beckmann's individual path across the artistic fashions he encountered. He was stubborn enough never to participate in any particular movement except for that of social criticism in the years around 1920, though he paid a heavy price for not following the crowd or being a representative of an accepted ism. After 1933 he had no choice other than to follow his own direction. The political situation and his subsequent emigration led him into utter isolation, which seemed to him the dramatization of what was to be expected in human life. Much later, when figurative art became acceptable again in the sixties and seventies, Beckmann enjoyed an increased popularity because he had not been identified with any of the artistic styles of the earlier twentieth century.

It does not come as a surprise that issues of visual perception never were a problem for Beckmann as they were for Duchamp and Magritte. The traps inherent in the exercises of the eye simply were not worth his consideration. Instead representation was a matter of personal expression for him. Painting resembled stage directing, for which Beckmann had such an affinity. What he needed was a convincing play for which he was both writer and director. Life was rich enough in themes and topics. These became transparent at another, deeper level, when Beckmann without hesitation introduced mythical figures among everyday figures. This mythical intrusion was a practice borrowed from the tradition of earlier painting and from literature, both poetic and theosophic.

Beckmann's stance as an artist had its German roots. But although Expressionism was never far from his mind, he never formally joined its ranks. Because of his independence from a particular stylistic idiom he became one of the most important European painters of his day. As such he was welcomed when he arrived in the United States after the war. His acceptance of the great tradition of European art—which was a heavy burden under the conditions of modernism—obliged him to act as a painter in the traditional way. It is precisely this self-conception that makes it possible for art historians today to deal with his intentions. The subtitle of this book is meant to express this focus: tradition as a problem for modernism in art. The art historian can elucidate the sources and inspirations as well as the reasoning of Beckmann's art in light of what Beckmann understood as the heritage of art that he must keep alive.

TEXTS BY
MAX BECKMANN

AUTOBIOGRAPHY

May 19, 1924

1. Beckmann is not a very nice man.

2. Beckmann had the bad luck not to have been endowed by nature with a money-making talent, but rather with a talent for painting.

3. Beckmann is hardworking.

4. Beckmann went through his basic training as a proper middle-class European in Weimar, Florence, Paris, and Berlin.

5. Beckmann loves Bach, Pelikan (the ink and oil-paint manufacturer), Piper (the publisher), and two or three other Germans.

6. Beckmann is a Berliner and lives in Frankfurt am Main.

7. Beckmann got married in Graz.

8. Beckmann is wild about Mozart.

9. Beckman suffers from an unshakable weakness for that faulty invention "life." The new theory that the earth's atmosphere is surrounded by a massive shell of frozen adhesive gives him cause for concern.

10. Nevertheless, Beckmann has recently discovered the beneficent effects of southern exposure. Even the theory of meteors puts his heart at rest.

11. Beckmann still sleeps very well.

"Autobiographie" is from a book without a title published in sixty copies for R. Piper & Co., on the occasion of the twentieth anniversary of the publishing house.

THE ARTIST IN THE STATE

1927

The artist in the contemporary sense is the conscious shaper of the transcendent idea. He is at one and the same time the shaper and the vessel. His activity is of vital significance to the state, since it is he who establishes the boundaries of a new culture. Without a universal new transcendent idea the very notion of a new state is incomplete. The concept of a state must first be derived from this transcendent idea, and the contemporary artist is the true creator of a world that did not exist before he gave shape to it. Self-reliance is the new idea that the artist, and with him, humanity, must grasp and shape. Autonomy in the face of eternity. The goal must be the resolution of the mystic riddle of balance, *the final deification of man.*

Should this goal be achieved in a work of art, then the work itself becomes a symbol and an energy-engendering medium for the development of the partially still-slumbering forces in the responsible man. Appraisal of the finished product is an aesthetic question to be measured according to the highest degree of the collective vitality of the engendered balance. In this sense, artist and statesman are both components of the overall process, since like the artist, the statesman seeks the realization of the transcendent idea in the concrete expressive product of the effected balance, that is, in the organization of the state.

Law on the one hand and the complete achievement of balance on the other are the essence of humanity's goal. Should this goal ever be achieved, the cosmic game in which we are now engaged will come to an end and a new one will begin, in the face of which deified humanity will once again disguise its true role.

Humanity's first revolutionaries perceived their primary purpose as a struggle against God. They adopted more or less the role of Prometheans or other delinquent angels. We fought against God, we swore at him, we hated him, or we ridiculed him—depending on our inclination or talent. Let us realize at last that we were always fighting only against ourselves. We no longer have anything to expect from without, only still from within. For we are God—by Jove, perhaps an altogether inadequate and pathetic God, but God all the same.

The collective intellectual products of humanity constitute God. This is and always has been the case. God is the collective consciousness of the world conceived in eternal evolution—or as I would rather put it, in its eternal unraveling. Its thermometer, the gauge of its

achieved balance or its accomplishment, is embodied in art, and thereafter in all the other products of the human brain.

What we have here is a picture of ourselves. Art is the mirror of God embodied by man. The fact cannot be denied that this mirror has in the past been greater and more rousing than it is today. Yet we know that even childhood in its innocent fashion sometimes engenders things that are often more beautiful than all the works of grown-ups. I view the period of humanity in which we live today as the transitional age from humanity's youth to its manhood. We are just beginning to be grown-up, and in the process permit some beautiful dreams of our youth to fall by the wayside. But no one can deny the fact that even the adult has it in his power to apply his consciousness to the creation of things that may yet surpass the shimmer of the muffled magnificence of our childhood achievements (in India, China, Egypt, and Europe's Middle Ages). We have arrived at this transitional juncture. The old gods lie in smithereens at our feet, and the old churches in their twilight perpetuate a dark, unreal, deceptive sham existence.

Chastened and devoid of all faith, matured into its adulthood, humanity stares into the empty void, not yet aware of its strength.

What we're missing is a new cultural center, a new center of faith. We need new buildings where we can practice this new faith and this new cult of man's balance, buildings in which to collect and present all that has become whole as a consequence of our newly acquired balance. What we are after is an elegant mastery of the metaphysical, so as to live a stalwart, clear, disciplined romanticism of our own profoundly unreal existence. The new priests of this new cultural center must be dressed in dark suits or on state occasions appear in tuxedo, unless we succeed in developing a more precise and elegant piece of manly attire. Workers, moreover, should likewise appear in tuxedo or tails. Which is to say: We seek a kind of aristocratic Bolshevism. A social equalization, the fundamental principle of which, however, is not the satisfaction of pure materialism, but rather the conscious and organized drive to become God ourselves. The external sign of success in this state system would no longer or only secondarily consist in money; the collective approbation would go to the individual who had achieved the greatest sum of balance and who would merit the greatest degree of power and influence. Power and influence are to be assigned on the basis of self-reliance. I am well aware that all this is a utopian vision. But someone has to make the first step, if only in the realm of ideas.

If we are not willing to adopt the faith that one day in the course of human development we ourselves will become God, that we will be

free, that we will finally and clearly recognize or see through that incomprehensible, weak, and impossible charade that we still call life, see it in all its hidden expediency—then the entire flux of humanity will from the very beginning have been nothing but a foolish farce. To focus this transcendent wish, we must join together. To strengthen this faith and transform it into reality, we must create the new art form, the new state form. This shared hope, this common faith will be the new core of what in olden times was filled by the longing for redemption through God's intercession. What we want today is to believe in ourselves. To be God, each one of us must share responsibility for the development of the whole. We can no longer depend on anything other than ourselves.

Children must already learn in school that they themselves are God. The purpose of such instruction is to free every creature from its metaphysical dependence and to make it reliant upon itself. Only in this way can the essential and new strengths of humanity be unleashed, the strengths that will bring the eternally fluctuating generations of man, which we embody, to a final standstill, allowing for a free state of being.

If the practically impossible were possible again, if we could build a new center of faith, then surely it would be this one. And it is imperative that we establish that new center, lest mankind sink into the foulest morass it has ever known. In accordance with this new faith, it is essential that the aesthetic education of humanity be far more strenuously pursued in childhood. The recognition of the law of balance in art, whether in painting, poetry, music, or sculpture, is an essential complement to the moral lesson of self-reliance and self-deification. Here is the basis for the transcendent positive potential perceived through the balance achieved in the work of art. This is a replacement for prayer. Our purpose is the last and final focus of the new and ultimate religion of mankind. Oh, our goal is still far off —how well I know it!—but let us harbor the thought, even if the center of which we speak is today still a utopia. We ourselves are the future generations and all those to come. We will re-encounter this resolve in the next life, and it will help us—indeed, it will continue to help us emerge from this pathetic slave's existence we now call life. Locked up like children in a dark room, we sit, beholden to God, waiting for the door to be opened, waiting to be led off to our execution, our death. Only when the faith becomes firmly established that we ourselves have a say in the outcome of our lives, only then will our self-reliance grow stronger. Only by combating the weak, the egoistic, and so-called evil in ourselves for the sake of universal love will we

succeed together as one humanity in achieving those great and decisive works; only then will we find the strength in ourselves to become God—that is, to be free, to decide for ourselves whether to live or to die. Only then will we become the conscious masters of eternity—free from time and space.

This is humanity's goal. Humanity's new faith, new hope, new religion. Bolshevism took the first steps toward the fulfillment of this vision by the state. Yet what Bolshevism lacks is art and a new faith. It lacks centralization—the dogmatic centralization of this faith, as well as a centralization of art in this faith.

"Der Kunstler im Staat" was first published in *Europaische Revue*, 3 (1927), pp. 288ff.

THE SOCIAL STANCE OF THE ARTIST
BY THE BLACK TIGHTROPE WALKER

1927

1. The talent for self-promotion is a prerequisite for those inclined to pursue the artistic calling.

2. The budding genius must learn above all else to respect money and power.

3. A reverence for critical authority must dominate his life. He must strictly adhere to his subservient standing, and never forget that art is merely an object the purpose of which is to facilitate the critic's realization of his critical potential.

4. The riskiest thing an artist can have is too strong a backbone. Woe betide that miserable creatively inclined creature not able to subdue his obdurate spinal column in the course of daily bowing and scraping.

5. Let him therefore take cognizance of the fact that he is a subservient member of society, nothing more in essence than a slightly better employee. His demands, can, of course, be taken under consideration only when society's more essential needs for a family car and a vacation trip to the Pyramids have been satisfied.

6. The artist may take quiet pleasure in his craft. Let him not, however, forget that fashion changes every five years. He would therefore do well not to indulge in all that much "quiet pleasure," and stay well informed of every new set of marching orders.

7. Aside from the talent for self-promotion, the most important asset an artist can have is a girlfriend or a beautiful wife. Her utility can be imagined in a variety of ways. Who other than the artist's beloved could better soothe the transaction-riddled, multinational-takeover-scheme–saturated, cosmic thunder–stricken brain of the champagne manufacturer or leather dealer? With her gentle hand she can stroke the mighty one's chaotic brow and, resting him against her soft body, induct him into the mysteries of dreaming and art.

8. The artist can know nothing of religion, politics, and life. He must not forget that sylphlike presence which he is, his only purpose consisting in sprinkling the world with brightly colored pollen. He must serve the amusement and the delight of the mighty. The "merry little artist folk" had best keep in mind their humble limitations. It is therefore advised that should the unfortunate artist have been endowed by nature with a little sense and a modicum of critical faculty, he keep these qualities to himself. Only insofar as he maintains an aura of artlessness can the artist expect to be recognized by the public.

9. The best thing an artist can do, of course, is to die. Only when the last living vestige of this bothersome personality has disintegrated in his grave can his fellow men take pleasure in his work. Only then does the artist's work truly belong to his contemporaries, for if they buy it at the right time it is as good as if they had made it. The artist is therefore strongly advised to die at the right time. Only thereby can he put the finishing touches on his work.

10. The artist who follows these fundamental precepts will have a good life. His fellow men will gladly accord this well-respected and untroublesome element in the fabric of the state all the love and recognition he deserves.

According to the artist's son, Peter Beckmann, this text was found in the same envelope and written with the same typewriter as "The Artist in the State." It was issued by P. Beckmann as an extract, "Sonderdruck für Teilnehmer der Pirckheimer-Jarhestreffens vom 25. bis 27 mai 1984 in Cottbus" published by Reclam Verlag in Leipzig.

ON MY PAINTING

1938

Before I begin to give you an explanation, an explanation which it is nearly impossible to give, I would like to emphasize that I have never been politically active in any way. I have tried only to realize my conception of the world as intensely as possible.

Painting is a very difficult thing. It absorbs the whole man, body and soul—thus I have passed blindly many things which belong to real and political life.

I assume, though, that there are two worlds: the world of spiritual life and the world of political reality. Both are manifestations of life which may sometimes coincide but are very different in principle. I must leave it to you to decide which is the more important.

What I want to show in my work is the idea that hides itself behind so-called reality. I am seeking the bridge which leads from the visible to the invisible, like the famous cabalist who once said: "If you wish to get hold of the invisible you must penetrate as deeply as possible into the visible."

My aim is always to get hold of the magic of reality and to transfer this reality into painting—to make the invisible visible through reality. It may sound paradoxical, but it is, in fact, reality which forms the mystery of our existence.

What helps me most in this task is the penetration of space. Height, width, and depth are the three phenomena which I must transfer into one plane to form the abstract surface of the picture, and thus to protect myself from the infinity of space. My figures come and go, suggested by fortune or misfortune. I try to fix them divested of their apparent accidental quality.

One of my problems is to find the self, which has only one form and is immortal—to find it in animals and men, in the heaven and in the hell which together form the world in which we live.

Space, and space again, is the infinite deity which surrounds us and in which we are ourselves contained.

That is what I try to express through painting, a function different from poetry and music but, for me, predestined necessity.

When spiritual, metaphysical, material, or immaterial events come into my life, I can fix them only by way of painting. It is not the subject which matters but the translation of the subject into the abstraction of the surface by means of painting. Therefore I hardly need to abstract things, for each object is unreal enough already, so unreal that I can make it real only by means of painting.

Often, very often, I am alone. My studio in Amsterdam, an enormous old tobacco storeroom, is again filled in my imagination with figures from the old days and from the new, like an ocean moved by storm and sun and always present in my thoughts.

Then shapes become beings and seem comprehensible to me in the great void and uncertainty of the space which I call God.

Sometimes I am helped by the constructive rhythm of the cabala, when my thoughts wander over Oannes Dagon to the last days of drowned continents. Of the same substance are the streets with their men, women, and children; great ladies and whores; servant girls and duchesses. I seem to meet them, like doubly significant dreams, in Samothrace and Piccadilly and Wall Street. They are Eros and the longing for oblivion.

All these things come to me in black and white like virtue and crime. Yes, black and white are the two elements which concern me. It is my fortune, or misfortune, that I can see neither all in black nor all in white. One vision alone would be much simpler and clearer, but then it would not exist. It is the dream of many to see only the white and truly beautiful, or the black, ugly and destructive. But I cannot help realizing both, for only in the two, only in black and in white, can I see God as a unity creating again and again a great and eternally changing terrestrial drama.

Thus without wanting it, I have advanced from principle to form, to transcendental ideas, a field that is not at all mine, but in spite of this I am not ashamed.

In my opinion all important things in art since Ur of the Chaldees, since Tel Halaf and Crete have always originated from the deepest feeling about the mystery of Being. Self-realization is the urge of all objective spirits. It is this self that I am searching in my life and in my art.

Art is creative for the sake of realization, not for amusement; for transfiguration, not for the sake of play. It is the quest of our self that drives us along the eternal and never-ending journey we must all make.

My form of expression is painting; there are, of course, other means to this end, such as literature, philosophy, or music; but as a painter, cursed or blessed with a terrible and vital sensuousness, I must look for wisdom with my eyes. I repeat, with my eyes, for nothing could be more ridiculous or irrelevant than a "philosophical conception" painted purely intellectually without the terrible fury of the senses grasping each visible form of beauty and ugliness. If from those forms which I have found in the visible, literary subjects result—such as portraits, landscapes, or recognizable compositions—they have all

originated from the senses, in this case from the eyes, and each intellectual subject has been transformed again into form, color, and space.

Everything intellectual and transcendent is joined together in painting by the uninterrupted labor of the eyes. Each shade of a flower, a face, a tree, a fruit, a sea, a mountain is noted eagerly by the intensity of the senses, to which is added, in a way of which we are not conscious, the work of the mind, and in the end the strength or weakness of the soul. It is this genuine, eternally unchanging center of strength which makes mind and senses capable of expressing personal things. It is the strength of the soul which forces the mind to constant exercise to widen its conception of space.

Something of this is perhaps contained in my pictures.

Life is difficult, as perhaps everyone knows by now. It is to escape from these difficulties that I practice the pleasant profession of a painter. I admit that there are more lucrative ways of escaping the so-called difficulties of life, but I allow myself my own particular luxury, painting.

It is, of course, a luxury to create art and, on top of this, to insist on expressing one's own artistic opinion. Nothing is more luxurious than this. It is a game and a good game, at least for me; one of the few games which make life, difficult and depressing as it is sometimes, a little more interesting.

Love in an animal sense is an illness, but a necessity which one has to overcome. Politics is an odd game, not without danger I have been told, but certainly sometimes amusing. To eat and to drink are habits not to be despised, but often connected with unfortunate consequences. To sail around the earth in ninety-one hours must be very strenuous, like racing in cars or splitting the atom. But the most exhausting thing of all—is boredom.

So let me take part in your boredom and in your dreams while you take part in mine, which may be yours as well.

To begin with, there has been enough talk about art. After all, it must always be unsatisfactory to try to express one's deeds in words. Still we shall go on and on, talking and painting and making music, boring ourselves, exciting ourselves, making war and peace as long as our strength of imagination lasts. Imagination is perhaps the most decisive characteristic of mankind. My dream is the imagination of space—to change the optical impression of the world of objects by a transcendental arithmetic progression of the inner being. That is the precept. In principle any alteration of the object is allowed which has a sufficiently strong creative power behind it. Whether such alteration causes excitement or boredom in the spectator is for you to decide.

The uniform application of a principle of form is what rules me in

the imaginative alteration of an object. One thing is sure—we have to transform the three-dimensional world of objects into the two-dimensional world of the canvas.

If the canvas is filled only with two-dimensional conception of space, we shall have applied art, or ornament. Certainly this may give us pleasure, though I myself find it boring, as it does not give me enough visual sensation. To transform three into two dimensions is for me an experience full of magic in which I glimpse for a moment that fourth dimension which my whole being is seeking.

I have always on principle been against the artist's speaking about himself or his work. Today neither vanity nor ambition causes me to talk about matters which generally are not to be expressed even to oneself. But the world is in such a catastrophic state and art is so bewildered that I, who have lived the last thirty years almost as a hermit, am forced to leave my snail's shell to express these few ideas which, with much labor, I have come to understand in the course of the years.

The greatest danger which threatens mankind is collectivism. Everywhere attempts are being made to lower the happiness and the way of living of mankind to the level of termites. I am against these attempts with all the strength of my being.

The individual representation of the object, treated sympathetically or antipathetically, is highly necessary and is an enrichment to the world of form. The elimination of the human relationship in artistic representation causes the vacuum which makes all of us suffer in various degrees—an individual alteration of the details of the object represented is necessary in order to display on the canvas the whole physical reality.

Human sympathy and understanding must be reinstated. There are many ways and means to achieve this. Light serves me to a considerable extent on the one hand to divide the surface of the canvas, on the other to penetrate the object deeply.

As we still do not know what this self really is, this self in which you and I in our various ways are expressed, we must peer deeper and deeper into its discovery. For the self is the great veiled mystery of the world. Hume and Herbert Spencer studied its various conceptions but were not able in the end to discover the truth. I believe in it and in its eternal, immutable form. Its path is, in some strange and peculiar manner, our path. And for this reason I am immersed in the phenomenon of the Individual, the so-called whole Individual, and I try in every way to explain and present it. What are you? What am I? Those are the questions that constantly persecute and torment me and perhaps also play some part in my art.

Color, as the strange and magnificent expression of the inscrutable spectrum of Eternity, is beautiful and important to me as a painter; I use it to enrich the canvas and to probe more deeply into the object. Color also decided, to a certain extent, my spiritual outlook, but it is subordinated to light and, above all, to the treatment of form. Too much emphasis on color at the expense of form and space would make a double manifestation of itself on the canvas, and this would verge on craft work. Pure colors and broken tones must be used together, because they are the complements of each other.

These, however, are all theories, and words are too insignificant to define the problems of art. My first unformed impression, and what I would like to achieve, I can perhaps realize only when I am impelled as in a vision.

One of my figures, perhaps one from *Temptation*, sang this strange song to me one night—

Fill up your mugs again with alcohol, and hand up the largest of them to me. . . . In ecstasy I'll light the great candles for you now in the night, in the deep black night. We are playing hide-and-seek, we are playing hide-and-seek across a thousand seas, we gods . . . when the skies are red in the middle of the day, when the skies are red at night.

You cannot see us, no you cannot see us but you are ourselves. . . . That is what makes us laugh so gaily when the skies are red in the middle of the night, red in the blackest night.

Stars are our eyes and the nebulae our beards. . . . We have people's souls for our hearts. We hide ourselves and you cannot see us, which is just what we want when the skies are red at midday, red in the blackest night.

Our torches stretch away without end . . . silver, glowing purple, violet, green-blue, and black. We bear them in our dance over the seas and the mountains, across the boredom of life.

We sleep and our brains circle in dull dreams. . . . We wake and the planets assemble for the dance across bankers and fools, whores and duchesses.

Thus the figure from my *Temptation* sang to me for a long time, trying to escape from the square on the hypotenuse in order to achieve a particular constellation of the Hebrides, to the Red Giants and the Central Sun.

And then I awoke and yet continued to dream. . . . Painting constantly appeared to me as the one and only possible achievement. I thought of my grand old friend Henri Rousseau, that Homer in the porter's lodge whose prehistoric dreams have sometimes brought me near the gods. I saluted him in my dream. Near him I saw William

Blake, noble emanation of English genius. He waved friendly greetings to me like a super-terrestrial patriarch. "Have confidence in objects," he said. "Do not let yourself be intimidated by the horror of the world. Everything is ordered and right and must fulfill its destiny in order to attain perfection. Seek this path and you will attain from your own self ever deeper perception of the eternal beauty of creation; you will attain increasing release from all that which now seems to you sad or terrible."

I awoke and found myself in Holland in the midst of a boundless world turmoil. But my belief in the final release and absolution of all things, whether they please or torment, was newly strengthened. Peacefully I laid my head among the pillows . . . to sleep, and dream, again.

LETTERS TO A WOMAN PAINTER

1948

I

To be sure it is an imperfect, not to say a foolish, undertaking to try to put into words ideas about art in general, because, whether you like it or not, every man is bound to speak for himself and for his own soul. Consequently, objectivity or fairness in discussing art is impossible. Moreover, there are certain definite ideas that may be expressed only by art. Otherwise, what would be the need for painting, poetry, or music? So in the last analysis, there remains only a faith, that belief in the individual personality which, with more or less energy or intelligence, puts forward its own convictions.

Now you maintain that you have this faith and you want to concentrate it upon my personality and you want to partake of my wisdom. Well, I must admit that at times you are really interested in painting and I cannot suppress a sort of feeling of contentment that you have this faith, even though I am convinced that your really deep interest in art is not yet too much developed. For, sadly, I have often observed that fashion shows, bridge teas, tennis parties, and football games absorb a great deal of your interest and lead your attentions into idle

ways. Be that as it may. You are pretty and attractive, which in a way is regrettable, for I am forced to say a few things to you that, frankly, make me a bit uncomfortable.

In the development of your taste you have already left behind certain things: those fall landscapes in brown and wine red, and those especially beautiful and edible still lifes of the old Dutch school no longer tempt you as they did before. Yes, as you have assured me, even those prismatic constructions, pictures of recent years, give you that sad feeling of boredom that you so much want to get rid of. And yet formerly you were so proud of understanding these things alone.

And now. What now? There you stand not knowing your way in or out. Abstract things bore you just as much as academic perfections, and ruefully you let your eyes fall on the violet red of your nail polish as if it were the last reality that remained to you! But in spite of it all, don't despair. There are still possibilities, even though they are at the moment somewhat hidden. I know very well that in the realm of pure concentration your greatest enemies are the evils of the big wide world: motor cars, photographs, movies—all those things that more or less consciously take away from people the belief in their own individuality and their transcendent possibilities and turn them into stereotyped men.

However, as I have said, we need not give up the hope of searching and finding the way out of the dark circle of machine phantoms in order to arrive at a higher reality. You can see that what you need is difficult to express in words, for what you need are just the things that, in a sense, constitute the grace and gift for art. The important thing is first of all to have a real love for the visible world that lies outside ourselves as well as to know the deep secret of what goes on within ourselves. For the visible world in combination with our inner selves provides the realm where we may seek infinitely for the individuality of our own souls. In the best art this search has always existed. It has been, strictly speaking, a search for something abstract. And today it remains urgently necessary to express even more strongly one's own individuality. Every form of significant art from Bellini to Henri Rousseau has ultimately been abstract.

Remember that depth in space in a work of art (in sculpture, too, although the sculptor must work in a different medium) is always decisive. The essential meaning of space or volume is identical with individuality, or that which mankind calls God. For in the beginning there was space, that frightening and unthinkable invention of the Force of the Universe. Time is the invention of mankind; space or volume, the palace of the gods.

But we must not digress into metaphysics or philosophy. Only do not forget that the appearance of things in space is the gift of God, and if this is disregarded in composing new forms, then there is the danger of your work's being damned by weakness or foolishness, or at best it will result in mere ostentation or virtuosity. One must have the deepest respect for what the eye sees and for its representation on the area of the picture in height, width, and depth. We must observe what may be called the Law of Surface, and this law must never be broken by using the false technique of illusion. Perhaps then we can find ourselves, see ourselves in the work of art. Because ultimately, all seeking and aspiration end in finding yourself, your real self, of which your present self is only a weak reflection. There is no doubt that this is the ultimate, the most difficult exertion that we poor men can perform. So with all this work before you, your beauty culture and your devotion to the external pleasures of life must suffer. But take consolation in this: you still will have ample opportunity to experience agreeable and beautiful things, but these experiences will be more intense and alive if you yourself remain apart from the senseless tumult and bitter laughter of stereotyped mankind.

Some time ago we talked about intoxication with life. Certainly art is also an intoxication. Yet it is a disciplined intoxication. We also love the great oceans of lobsters and oysters, virgin forests of champagne, and the poisonous splendor of the lascivious orchid.

But more of that in the next letter.

II

It is necessary for you, you who now draws near to the motley and tempting realm of art, it is very necessary that you also comprehend how close to danger you are. If you devote yourself to the ascetic life, if you renounce all worldly pleasures, all human things, you may, I suppose, attain a certain concentration: but for the same reason you may also dry up. Now on the other hand, if you plunge headlong into the arms of passion, you may just as easily burn yourself up! Art, love, and passion are very closely related because everything revolves more or less around knowledge and the enjoyment of beauty in one form or another. And intoxication is beautiful, is it not, my friend?

Have you not sometimes been with me in the deep hollow of the champagne glass where red lobsters crawl around and black waiters serve red rumbas which make the blood course through your veins as if to a wild dance? Where white dresses and black silk stockings nestle themselves close to the forms of young gods amidst orchid blossoms

and the clatter of tambourines? Have you never thought that in the hellish heat of intoxication amongst princes, harlots, and gangsters, *there* is the glamour of life? Or have not the wide seas on hot nights let you dream that we were glowing sparks on flying fish far above the sea and the stars? Splendid was your mask of black fire in which your long hair was burning—and you believed, at last, at last, that you held the young god in your arms who would deliver you from poverty and ardent desire?

Then came the other thing—the cold fire, the glory.

Never again, you said, never again shall my will be slave to another. Now I want to be alone, alone with myself and my will to power and to glory.

You have built yourself a house of ice crystals and you have wanted to forge three corners or four corners into a circle. But you cannot get rid of that little "point" that gnaws in your brain, that little "point" which means "the other one." Under the cold ice the passion still gnaws, that longing to be loved by another, even if it should be on a different plane from the hell of animal desire. The cold ice burns exactly like the hot fire. And uneasy you walk alone through your palace of ice. Because you still do not want to give up the world of delusion, that little "point" still burns within you—the other one! And for that reason you are an artist, my poor child! And on you go, walking in dreams like myself. But through all this we must also persevere, my friend. You dream of my own self in you, you mirror of my soul.

Perhaps we shall awake one day, alone or together. This we are forbidden to know. A cool wind beyond the other world will awake us in the dreamless universe, and then we shall see ourselves freed from the danger of the dark world, the glowing fields of sorrow at midnight. Then we are awake in the realm of atmospheres, and self-will and passion, art and delusion are sinking down like a curtain of gray fog . . . and light is shining behind an unknown gigantic gleam.

There, yes there, we shall perceive all, my friends, alone or together . . . who can know?

III

I must refer you to Cézanne again and again. He succeeded in creating an exalted Courbet, a mysterious Pissarro, and finally a powerful new pictorial architecture in which he really became the last old master, or I might better say he became the first "new master" who stands synonymous with Piero della Francesca, Uccello, Grünewald, Orcagna, Titian, Greco, Goya, and van Gogh. Or, looking at quite a

different side, take the old magicians. Hieronymous Bosch, Rembrandt, and as a fantastic blossom from dry old England, William Blake, and you have quite a nice group of friends who can accompany you on your thorny way, the way of escape from human passion into the fantasy palace of art.

Don't forget nature, through which Cézanne, as he said, wanted to achieve the classical. Take long walks and take them often, and try your utmost to avoid the stultifying motor car which robs you of your vision, just as the movies do, or the numerous motley newspapers. Learn the forms of nature by heart so you can use them like the musical notes of a composition. That's what these forms are for. Nature is a wonderful chaos to be put into order and completed. Let others wander about, entangled and color blind, in old geometry books or in problems of higher mathematics. We will enjoy ourselves with the forms that are given us: a human face, a hand, the breast of a woman or the body of a man, a glad or sorrowful expression, the infinite seas, the wild rocks, the melancholy language of the black trees in the snow, the wild strength of spring flowers, and the heavy lethargy of a hot summer day when Pan, our old friend, sleeps and the ghosts of midday whisper. This alone is enough to make us forget the grief of the world, or to give it form. In any case, the will to form carries in itself one part of the salvation you are seeking. The way is hard and the goal is unattainable; but it is a way.

Nothing is further from my mind than to suggest to you that you thoughtlessly imitate nature. The impression nature makes upon you in its every form must always become an expression of your own joy or grief, and consequently in your formation of it, it must contain that transformation which only then makes art a real abstraction.

But don't overstep the mark. Just as soon as you fail to be careful you get tired, and though you still want to create, you will slip off either into thoughtless imitation of nature, or into sterile abstractions which will hardly reach the level of decent decorative art.

Enough for today, my dear friend. I think much of you and your work and from my heart wish you power and strength to find and follow the good way. It is very hard with its pitfalls left and right. I know that. We are all tightrope walkers. With them it is the same as with artists, and so with all mankind. As the Chinese philosopher Lao-tse says, we have "the desire to achieve balance, and to *keep* it."

"Letters to a Woman Painter" was written in response to an invitation to lecture at Stephens College, Columbia, Missouri. The "letters" were translated by Mathilde Q. Beckmann and Perry Rathbone and read by Mrs. Beckmann on February 3, 1948. They were published in *College Art Journal*, 9, no. 1 (Autumn 1949), pp. 39–43.

SPEECH FOR THE FRIENDS AND PHILOSOPHY
FACULTY OF WASHINGTON UNIVERSITY

June 6, 1950

It is a great pleasure for me to meet again the circle of friends who have shared with me my first impressions of America.

While my Pullman car called the Silver Cascade thundered over the Mississippi, the memories of my first arrival in St. Louis came vividly to my mind. I thought of the beautiful river paintings of George Catlin as I saw the big yellow river again, downtown St. Louis, and later, in rapid succession, all the other landmarks: the lovely park, the Jefferson Memorial, the Art School, the University and the City Art Museum with its beautiful treasures. And many thoughts which I had pondered over then came back to me. As always and as in everything, the eternal link are the arts—music, painting, poetry, and architecture. When I now walk under the blossoming trees of Central Park, so carefully guarded by Manhattan's towering skyscrapers, I often think of those first, unforgettable days here. You cannot imagine the complete change the arrival in this peaceful country produced within me after having had to witness the terrible destruction wrought in Europe. But as everything in life of necessity undergoes a change, the pleasant time here had to end, but for all the more reason it has impressed itself so strongly on me.

Friends have asked me to say something about art during this reunion. Should one embark again on the discussion of this old theme which never arrives at a satisfactory conclusion because everyone can speak only for himself? Particularly the artist who, after all, can never escape his calling. Isn't it much nicer to go for a walk and experience the new, young dream of spring instead of getting entangled in dry theories or arriving at inconclusive results?

Indulge in your subconscious, or intoxicate yourself with wine (for all I care, love the dance, love joy and melancholy, and even death!). Yes, also death—as the final transition to the great unknown. But above all you should love, love, and love! Do not forget that every man, every tree, and every flower is an individual worth thorough study and portrayal.

And when you ask me again *how* should I make this study and portrayal, I can tell you again only that in art everything is a matter of discrimination, address, and sensibility, regardless of whether it is modern or not. Ever important are keen awareness and uncompromising self-criticism. The work must emanate truth. Truth through love of nature and iron self-discipline.

If you really have something to say, it will always be evident; therefore do not shy away from tears, from despair and the torment of hard work, for in spite of it all, there is no deeper satisfaction than to have accomplished something good, and therefore it is worth your while to sweat a bit.

This is all that might be said about painting. I do believe, however, that this very problem applies to all the arts and sciences. Purposely I have avoided commenting on the various art theories, as I am a sworn enemy of putting art in categories. Personally, I think it is high time to put an end to all isms, and to leave to the individual the decision whether a picture is beautiful, bad, or boring. Not with your ears shall you see but with your eyes.

Greatness can be achieved in every form of art; it depends alone on the fertile imagination of the individual to discover this. Therefore I say not only to the artist but also to the beholder: If you love nature with all your heart, new and unimaginable things in art will occur to you. Because art is nothing but the transfiguration of Nature.

Manhattan's skyscrapers nodded reflectively to my thoughts—some of them reared themselves even prouder than before. Right, they said, right—we too have become nature. Man-made—but grown above man—and slowly they vanished in the warm gray mist of a spring evening.

Art, with religion and the sciences, has always supported and liberated man on his path. Art resolves through form the many paradoxes of life, and sometimes permits us to glimpse behind the dark curtain which hides those unknown spaces where one day we shall be unified.

The speech was given on the occasion of receiving an honorary degree from Washington University. The typescript of this speech is in the University Archives and Research Collection, Washington University Libraries, St. Louis.

NOTES

CHAPTER 1

1. Munich/St. Louis.

2. Hausenstein in Glaser 1924, p. 69.

3. Göpel 1976, vol. 1, p. 15. On Beckmann and Munch, see Kaiser 1913, pp. 16f. At the time Kaiser criticized Munch's "erratic path," which everyone seemed to be following, as if form and content could be separated. On Beckmann's early work, see Frankfurt 1982, with the contributions of J. Poeschke, K. Gallwitz, and others, as well as Reifenberg 1949, pp. 12f.

4. See in particular the painting *The Battle* (1907), in the spirit of Michelangelo's *Battle of Cascina*, and *Battle of the Amazons* (1911), for which see Buenger 1984, pp. 140ff. See also Frankfurt 1982, nos. 30, 39.

5. Göpel 1976, no. 104, and Frankfurt 1982, no. 44. The painting is in the Staatsgalerie, Stuttgart. In addition see Günther F. Hartlaub, *Kunst und Religion* (1919), p. 84.

6. Göpel 1976, no. 190. The painting is in the Staatsgalerie, Stuttgart. See also Dube 1982, pp. 67ff, and Wiese 1978, pp. 100ff. On the remarks by Beckmann, see Piper 1950, pp. 19f.

7. Meier-Gräfe 1924, foreword.

8. Westheim 1923, p. 120.

9. Beckmann himself put some distance between the artist and his subjects in a 1920 portrait of his family, where he transformed the Ibsen-inspired drama of his early picture *Entertainment I* (1908), which shows the same family, into a dollhouse painted with stiffly stilted irony. See Göpel 1976, no. 207, and Munich/St. Louis 1984, no. 25, with a bibliography. The painting is in The Museum of Modern Art, New York.

10. Frankfurt 1983, p. 272, no. 14 (letter dated August 20, 1925).

11. Westheim 1923, pp. 99ff, and Einstein 1931, pp. 181ff.

12. One group tears the objectives from the world of actual fact and flings out experience according to its own tempo. The other seeks rather to isolate the atemporally valid object, so as to realize eternal laws of being in the realm of art. Proponents of both groups lay common claim to "the truth and the craft" of art in a period unsympathetic to its creation. See Günther F. Hartlaub, introduction to Mannheim 1925, and Roh 1925, passim.

13. Hausenstein 1928, introduction.

14. Meier-Gräfe 1929, unpaged.

15. Hausenstein 1928, introduction.

16. Lackner 1967, p. 51, offers a copy of the text, as well as an account of Lackner's acquaintanceship with Beckmann.

17. *Departure* was acquired by The Museum of Modern Art in 1942 but had been exhibited since 1938 in the United States (see Göpel 1976, no. 412). *Guernica* was first exhibited in New York in May 1939.

18. See the master's thesis by Lucy McCormick Embick, *The Expressionist Current in New York's Avant-Garde: The Paintings of the Ten* (University of Oregon, 1982). I thank the author for letting me know of it.

19. Reifenberg 1949, passim.

20. "Zeitvergleich: Malerei und Grafik aus der DDR" (Kunstverein Hamburg and elsewhere, 1982–1983), most notably the work of B. Hessig and S. Gille. The situation is altogether different in the West, where the Galerie Poll in Berlin invited artistic submissions for a contest (published in *Huldigung an M. Beckmann: 30 zeitgenössischen Maler und Bildhauer zum 100. Geburtstag*, 1984).

21. Göpel 1976, nos. 412, 460.

22. Six of Beckmann's texts are published in English translation at the end of this book. They are "Autobiography," "The Artist in the State," "The Social Stance of the Artist," "On My Painting," "Letters to a Woman Painter," and the speech Beckmann gave upon receiving an honorary degree from Washington University, St. Louis. For "Six Sentences on the Structure of Painting" see *Ausstellungs-Katalog: Max Beckmann. Das gesammelte Werk. Gemälde, Graphik, Handzeichnungen aus den Jahren 1905–1927* (Städtische Kunsthalle, Mannheim, 1928). For the diaries see Beckmann 1979, passim.

23. Härtling, on *Die Loge* (1928), in *Frankfurter Allgemeine Zeitung*, February 24, 1984.

CHAPTER 2

1. The painting is in The St. Louis Museum of Art. See Göpel 1976, no. 159; Frankfurt 1982, no. 64; Munich/ St. Louis 1984, no. 12. For an interpretation of the photograph of 1912, see K. Gallwitz in Frankfurt 1982, pp. 147ff.

2. Zurich, Kunsthaus. See Anne C. Hanson, *Manet and the Modern Tradition* (New Haven, 1977) pp. 124f and pl. 87.

3. Kaiser 1913, p. 28.

4. *The Flood* is in a private collection. See Göpel 1976, no. 97, and Frankfurt 1982, no. 39.

5. Meier-Gräfe 1919 (see also Beckmann 1962, pp. 50ff), and Meier-Gräfe in Glaser 1924, pp. 27ff.

6. *Pan*, 2 (March 1912) p. 502, reprinted in Frankfurt 1982, p. 34. On the controversy see D. Schubert in Frankfurt 1982, pp. 175ff, and Schubert 1983, pp. 207ff.

7. See note 6.

8. Letter dated March 3, 1939, reprinted in Frankfurt 1983, pp. 284ff.

9. On this subject see further in chapter 4.

10. This is the title of the exhibition organized by H. Szeemann in Zurich. What is meant here essentially is life as a total work of art.

11. See the conclusion of the 1932 essay "Nach dem Nihilismus" in Benn 1958, pp. 151ff. The goal here is the establishment of the "law of form," so as to compensate for the lost adherence to a style. In an interview with G. R. Lind in *Die Tat*, January 14, 1950 (see *Das Gottfried Benn Lesebuch*, ed. M. Niedermayer and M. Schlüter, 1982, p. 47), we read: "Style is superior to truth, it embodies the proof of existence." See also chapter 4.

12. Einstein 1931, pp. 181ff.

13. See p. 125.

14. See p. 123.

15. Göpel 1976, no. 232; Frankfurt 1983, no. 34, with color photo; Munich/St. Louis 1984, no. 30.

16. Westheim 1923, p. 24.

17. Roh 1925, p. 105.

18. See note 12.

19. Letter dated June 26, 1926, reprinted in Frankfurt 1983, pp. 274f.

20. Letter dated October 13, 1930, reprinted in Frankfurt 1983, p. 280.

21. Jean Cocteau, *Picasso* (Paris, 1923).

22. Oscar Schürer, *Pablo Picasso* (Berlin and Leipzig, 1927). The book bears the dedication: "Hernn Dr. h.c. G. F. Reber, dem Sammler der Kunst Picassos," and reproduces twenty of Picasso's paintings in the Reber Collection.

23. Göpel 1976, no. 233; Frankfurt 1983, no. 36; Munich/St. Louis 1984, no. 37. On Picasso's 1923 painting see Zervos, vol. 5, p. 53, and The Museum of Modern Art's catalogue *Pablo Picasso: A Retrospective* (New York, 1980), p. 243.

24. Letter dated August 9, 1924, reprinted in Frankfurt 1983, p. 270.

25. Letter dated August 26, 1925, reprinted in Frankfurt 1983, p. 273.

26. Göpel 1976, no. 255. Meier-Gräfe's appreciation in the *Frankfurter Zeitung* of September 8, 1926, is reprinted in Frankfurt 1983, p. 120.

27. Letter dated January 1, 1926, reprinted in Frankfurt 1983, p. 273.

28. Today the painting is in The Art Institute of Chicago. See Schürer, *Pablo Picasso*, fig. 26, where the painting is called *Mother and Child at the Sea*.

29. *Soccer Players* in Duisburg (Göpel 1976, no. 307; Frankfurt 1983, no. 71; Munich/St. Louis 1984, no. 56) is related in composition to Fernand Léger's "figure-machines" (Green 1976, pp. 223ff) and in theme to Robert Delaunay's *L'Équipe de Cardiff* of 1912–1913.

30. Göpel 1976, no. 304; Karlsruhe 1963, no. 30; Frankfurt 1983, no. 69. Curt Glaser, *Zwei Jahrhunderte deutscher Malerei* (Munich, 1916), pp. 98f, wrote of the "Mäleskircher" (the Master of the Tegernsee Crucifixion) in terms that could apply equally to Beckmann as one who stood in conscious opposition to his contemporaries and painted in accordance with tradition. Thus he succeeded in producing an opus that far surpassed all contemporary efforts in its imaginative power and greatness. Glaser was among those who bought Beckmann's work in Berlin. For his interpretation of Beckmann, see Glaser 1924, pp. 1ff.

31. Reproduced in the Centre Georges Pompidou's catalogue *Les Réalismes 1919–1939* (Paris, 1981), p. 130.

32. *Ausstellungs-Katalog: Max Beckmann* (Mannheim, 1928) reprinted in Frankfurt 1983, p. 19.

33. Göpel 1976, no. 306. See Frankfurt 1983, no. 70, and Cologne 1984, no. 20. On the collection of Picassos see note 22 above. For the collection of Cézannes see the images in Julius Meier-Gräfe, *Cézanne und sein Kreis* (Munich, 1922). For the portrait of Reber see Karlsruhe 1963, no. 29.

34. For *The Night* see Munich/St. Louis 1984, no. 174, and Bielefeld 1977, no. 123. For the *cassone* painting by Piero di Cosimo see M. Bacci, *Piero di Cosimo* (Milan, 1966), no. 28. For the comparison see Buenger 1979, pp. 144ff.

35. Göpel 1976, no. 334, and Munich/St. Louis 1984, no. 62.

36. Göpel 1976, no. 363; Munich/St. Louis 1984, no. 64; Lackner 1967, pp. 5f, 67; F. Fischer 1972 (I), pp. 91ff.

37. Göpel 1976, no. 381, and Munich/St. Louis 1984, no. 69.

CHAPTER 3

1. "On My Painting," pp. 119–121.
2. For *Gypsy Woman* see Göpel 1976, no. 289, and Munich/St. Louis 1984, no. 54. For *Sleeping Woman* see Göpel 1976, no. 227, and Munich/St. Louis 1984, no. 35.
3. See the catalogue *Georg Scholz* (Karlsruhe, 1975), no. 66 and fig. p. 149; also the Centre Georges Pompidou catalogue *Les Réalismes 1919–1939* (Paris, 1981) p. 133.
4. Bielefeld 1977, no. 123; Frankfurt 1982, no. 156; Munich/St. Louis 1984, no. 174.
5. Einstein 1970, pp. 51ff, particularly p. 52.
6. See above all Max Ernst and Salvador Dalí.
7. Westheim 1923, p. 24.
8. Göpel 1976, no. 269; Frankfurt 1983, no. 56; Munich/St. Louis 1984, no. 49; also Hausenstein 1928, unpaged.
9. Reifenberg 1949, pp. 23f, and Reifenberg 1970, pp. 15f. For the painting see Göpel 1976, no. 293, and Munich/St. Louis 1984, no. 50.
10. Göpel 1976, no. 296, and Munich/St. Louis 1984, no. 51.
11. Göpel 1976, no. 460, and F. Fischer 1972 (I), pp. 154, 189, and fig. 45.
12. Blumenberg 1981, p. 14.
13. Göpel 1976, no. 419, and Cologne 1984, no. 32. See also Reifenberg 1970, pp. 13f, and Erpel 1981, p. 16.
14. Göpel 1976, no. 257; Frankfurt 1983, no. 49; Buenger 1979, pp. 174ff, 182ff. See also Zenser 1984, pp. 20f for still lifes by Beckmann.
15. Göpel 1976, no. 338, and Zenser 1984, p. 20.
16. Göpel 1976, no. 180; Zenser 1984, no. 11; Munich/St. Louis 1984, no. 14.
17. Green 1976, pp. 298f, 305ff. It is above all in 1924 and 1925 that the subject plays a major role in Léger's oeuvre. See also the catalogue *Léger and Purist Paris* (London, 1971), pp. 53ff.
18. *Almanach*, Piper Verlag, 1924, n.p.
19. Göpel 1976, nos. 209, 231; Frankfurt 1983, nos. 15, 33; Munich/St. Louis 1984, nos. 27, 38. See also note 14 above, Buenger. For *Carnival* see Göpel 1976, no. 206; F. Fischer 1972 (II), pp. 16ff; and the exhibition catalogue of the Tate Gallery, London, 1984, with text by Sarah O'Brien.
20. Göpel 1976, no. 275; F. Fischer 1972 (I), pp. 59, 62, 118, and 1972 (II), pp. 42f; Buenger 1979, pp. 186ff, for the allusion to Brueghel. On the iconography of the five senses see H. Kauffman in *Kunstgeschichtliche Studien*, ed. H. Tintelnot (1943), pp. 133ff.
21. Rudolf and Margot Wittkower, *Born Under Saturn: The Character and Conduct of Artists* (New York, 1963).
22. See note 20 above, F. Fischer.
23. Oscar Schürer, *Pablo Picasso* (Berlin and Leipzig,

1927), fig. p. 37, and the Museum of Modern Art catalogue *Pablo Picasso: A Retrospective* (New York, 1980), fig. p. 249 (Zervos, vol. 5, p. 220).
24. Göpel 1976, no. 276; Munich/St. Louis 1984, no. 48; F. Fischer 1972 (I), p. 76. The path has already been paved for the division of the background, but applied horizontally. The Italian newspaper *Corriere della sera* lies beneath the brightly shimmering fish corpses, which we see from the flat surface only. The musical instrument echoes the flat tube forms in paintings by Léger.
25. Göpel 1976, no. 302, and Frankfurt 1983, no. 68.
26. Göpel 1976, no. 315; Munich/St. Louis 1984, no. 58; F. Fischer 1972 (I), pp. 69ff.

CHAPTER 4

1. "The Artist in the State," p. 112ff.
2. "Schöpferische Konfession," pub. K. Edschmid, (Berlin, 1918, 1920), pp. 61ff. Reprinted in Frankfurt 1983, p. 16.
3. Piper 1950, p. 19.
4. "The Social Stance of the Artist," p. 127f.
5. Beckmann saw this book in the third edition (Leipzig, 1936). Today the book is in the possession of Peter Beckmann, who very kindly allowed me to inspect it. The marginal notations quoted here are on pp. 113, 198, 193, respectively.
6. On pp. 192f of Beckmann's copy (see note 5), with the addition "Berlin Ende September 1936." The underlining was done by Beckmann.
7. The passages are mainly in the section "Uber die anscheinende Absichtlichkeit im Schicksal des Einzelnen."
8. In his "Versuch einer Selbstkritik," 1886, Nietzsche distanced himself from his early work, above all from his notion that art is the actual metaphysical function of man, which would lead to an artistic purpose as the basis of all events. This artist metaphysics belongs to him who can seek his redemption only in appearances.
9. "Letters to a Woman Painter," p. 122ff.
10. "On My Painting," p. 117.
11. Ibid., p. 120.
12. "Letters to a Woman Painter," p. 126.
13. "On My Painting," p. 118.
14. Letter dated January 3, 1932, reprinted in Frankfurt 1983, p. 284.
15. Letter dated March 3, 1939, reprinted in Frankfurt 1983, p. 285.
16. Indicated by Fritz Erpel, Berlin. Frau von Poroda had tried in 1933 to bring them together. See Gottfried Benn, *Den Traum alleine tragen*, ed. P. Raabe and M. Niedermayer (Weisbaden, 1966), pp. 118f, 131. On Benn see B. Hillebrand, *Artistik und Auftrag: Zur Kunsttheorie von Nietzsche und Benn* (1966), and *Gottfried Benn* (1979).

17. First published in *Dichterglaube*, ed. H. Braun (1931). See Benn 1961, pp. 235f.

18. First published in *Deutsche Zukunft*, November 5, 1933. See Benn 1958, pp. 240ff.

19. First published in *Der Vorstoss*, 2, 28 (1932). See Benn 1958, pp. 151ff.

20. Benn 1958, p. 99.

21. First published in *Die Literarische Welt*, 3, 38 (1927). See Benn 1958, pp. 41ff.

22. Einstein 1970, pp. 51ff. On Einstein see also H. Öhm, *Die Kunsttheorie Carl Einsteins* (Munich, 1976).

23. Einstein 1970, pp. 34ff.

24. K. Gallwitz, *Max Beckmann: Die Druckgraphik* (Karlsruhe, 1962), nos. 82b, 96; Hamburg 1979, pp. 58ff; Hannover 1983, nos. 70, 85; Leipzig 1984, nos. 42, 53; Munich/St. Louis 1984, nos. 233, 238. On this subject see also Sarah O'Brien-Twohig in Munich/St. Louis 1984, pp. 102ff.

25. See Berlin 1983, passim, in particular no. 66 and pp. 76ff (A. Dückers). See also Gallwitz, *Max Beckmann*, no. 113b; Hannover 1983, no. 102; Leipzig 1984, no. 66; Munich/St. Louis 1984, no. 247.

26. Gallwitz, *Max Beckmann*, no. 163; Hannover 1983, no. 147; Leipzig 1984, no. 99; Munich/St. Louis 1984, no. 271.

27. Göpel 1976, no. 274. See Frankfurt 1983, no. 54, and Munich/St. Louis 1984, no. 53, as well as O. Fischer 1930, pp. 91, 94; Julius Meier-Gräfe in *Frankfurter Zeitung*, April 18, 1928; and Carl Einstein in the second edition of his *Die Kunst des 20. Jahrhunderts* (1928), p. 168. See also the bibliography in Göpel 1976, vol. 1, p. 198; and among others, G. Jedlicka in Beckmann 1962, pp. 123f; F. Fischer 1972 (I), pp. 65ff; Erpel 1981, no. 12; Zenser 1984, pp. 18f; and Munich/St. Louis 1984, pp. 64f.

28. Zenser 1984, pp. 18f.

29. Göpel 1976, no. 255; Munich/St. Louis 1984, no. 44. On the meaning of this painting see the letter dated June 6, 1926, reprinted in Frankfurt 1983, p. 275.

30. Frankfurt 1983, p. 19.

31. Catalogue of the 1962 Berlin exhibition of George Grosz. See also *Realismus zwischen Revolution und Machtergreifung* (Stuttgart, 1971), fig. 50; *Les Réalismes 1919–1939* (Paris, 1981), p. 119; U. Schneede, *George Grosz* (Cologne, 1975).

32. Westheim 1923, p. 99.

33. Göpel 1976, no. 391; Cologne 1984, no. 27 and figs. 64f; Selz 1964, p. 55; F. Fischer 1972 (I), pp. 118f; Zenser 1984, no. 32.

34. Göpel 1976, nos. 434, 476; Zenser 1984, nos. 33, 38.

35. Göpel 1976, no. 489; Munich/St. Louis 1984, no. 86. See also Selz 1964, p. 72; F. Fischer 1972 (I), pp. 119ff; Zenser 1984, no. 39.

CHAPTER 5

1. See Blumenberg 1981, passim. For an overview of the investigation into myth and its meaning for modern spiritual history see W. Burkert in *Entretiens sur l'antiquité classique*, ed. O. Reverdin and B. Crange, vol. 26 (Genf 1979), pp. 159ff. On Beckmann and myth see F. Fischer 1972 (I), passim, especially pp. 45ff. On myth see also K. H. Bohrer, ed., *Mythos und Moderne* (Suhrkamp), and M. Frank, *Der kommende Gott* (Suhrkamp).

2. "On My Painting," p. 122.

3. Letter dated February 11, 1938, reprinted in Frankfurt 1983, p. 37.

4. See the following notes and note 1 above, Burkert.

5. Blumenberg 1981, passim.

6. Ibid., pp. 165ff.

7. Otto 1928, pp. 23ff.

8. Ibid., pp. 229, 368.

9. Otto 1933, p. 40.

10. Ibid., p. 46.

11. F. Fischer 1972 (I), p. 19 with notes 21, 53.

12. Otto 1928, pp. 227ff.

13. Arthur Schopenhauer, "Fragmente zur Geschichte der Philosophie," *Parerga und Paralipomena*.

14. Blumenberg 1981, pp. 199f.

15. H. Jonas, *Gnosis und spätantiker Geist. I. Die mythologische Gnosis* (Göttingen, 1934).

16. Ibid., pp. 106ff.

17. Ibid., p. 99.

18. Einstein 1970, pp. 51ff.

19. Ibid., p. 59. See André Breton, *Manifeste du surréalisme* (Paris, 1924). On myth and surrealism see W. Chadwick, *Myth in Surrealist Painting 1929–1939* (1980). See in particular Louis Aragon, *Le Paysan de Paris* (Paris, 1926), and Breton's album "De la survivance des certains mythes . . ." (New York, 1942).

20. On Oelze's painting, in The Museum of Modern Art in New York, see *Realismus zwischen Revolution und Reaktion*, (Munich, 1981; German edition of the catalogue *Les Réalismes 1919–1939*, Paris 1981), p. 141; and see C. Willink in the same book, pp. 176ff, 179.

21. Bielefeld 1977, no. 140; Frankfurt 1983, no. 166; Munich/St. Louis 1984, no. 179.

22. *Pablo Picasso: A Retrospective* (The Museum of Modern Art, New York, 1980), pp. 316f. See also note 19 above, Chadwick, chap. 3.

23. Otto 1933, pp. 153ff.

24. Selz 1964, p. 57.

25. Bielefeld 1977, no. 141, and Munich/St. Louis 1984, no. 178.

26. Göpel 1976, nos. 403, 312. See Munich/St. Louis 1984, no. 70; F. Fischer 1972 (I), pp. 121ff.

27. Göpel 1976, no. 646. See also F. Fischer 1972 (II), p. 69, and Selz 1964, p. 77.

28. Göpel 1976, no. 412. See also Frankfurt 1981, passim, with the observations by K. Gollwitz, P. Selz, and G. Schiff; F. Fischer 1972 (I), pp. 93ff, and 1972 (II), pp. 49ff; Lackner 1965, pp. 5f.

29. Göpel 1976, nos. 208, 247. See Frankfurt 1983, no. 16, and the interpretation by W. Fraenger in Glaser 1924, pp. 35ff; also F. Fischer 1972 (II), pp. 37f, and 1972 (I), pp. 26ff, 51ff.

30. Blumenberg 1981, pp. 192ff.

CHAPTER 6

1. Marginal note in a book by Johan Huizinga; see p. 51.

2. On this see Kesting 1970, passim.

3. As in "The Artist in the State," p. 112.

4. See p. 52.

5. Westheim 1923, pp. 99f.

6. Ibid., pp. 102, 104.

7. Glaser 1924, p. 33.

8. Ibid., p. 25.

9. O. Fischer 1930, pp. 89f.

10. Einstein 1931, pp. 181f.

11. Lackner 1967, pp. 51ff.

12. Gandelman 1978, pp. 472ff. See also Frankfurt 1981, pp. 102ff.

13. "On My Painting," p. 118.

14. Kesting 1970, pp. 13f. On the novel, see among others B. Hillebrand, *Zur Struktur des Romans* (1978).

15. Kesting 1970, p. 16.

16. Ibid., pp. 30, 39, 232ff.

17. Göpel 1976, no. 552; F. Fischer 1972 (I), pp. 42ff; K. Gallwitz in Frankfurt 1981, pp. xviif; Munich/St. Louis 1984, no. 94.

18. Göpel 1976, no. 789; F. Fischer 1972 (I), pp. 202ff; Frankfurt 1981, no. 8; Munich/St. Louis 1984, no. 122.

19. Göpel 1976, no. 236; Mannheim 1981, passim; Frankfurt 1983, no. 39; Cologne 1984, no. 16 and fig. pp. 48–49; Zenser 1984, no. 24. See also C. Schulz-Hoffmann in Munich/St. Louis 1984, p. 23.

20. Göpel 1976, no. 240; F. Fischer 1972 (I), pp. 40ff; Munich/St. Louis 1984, no. 43; Zenser 1984, no. 25.

21. See p. 30.

22. Ibid.

23. Göpel 1976, no. 403, and Munich/St. Louis 1984, no. 70.

24. Göpel 1976, no. 564; Hildegard Zenser, *Max Beckmanns Selbstbildnisse* (dissertation, Munich, 1981), pp. 171ff; Lenz 1972, pp. 213ff; Munich/St. Louis 1984, no. 95; Zenser 1984, no. 43.

25. Beckmann 1979, p. 26.

26. "On My Painting," p. 120.

27. Ibid.

28. "Letters to a Woman Painter," p. 123.

29. Ibid., p. 124.

30. See p. 77.

31. Conversation with Peter Beckmann.

32. Frankfurt 1981, no. 5 and passim; Göpel 1976, no. 604. The triptych is now in the Busch-Reisinger Museum of Harvard University.

33. Göpel 1976, no. 208; Frankfurt 1983, no. 16; Munich/St. Louis 1984, no. 23. The most important interpretation is that by W. Fraenger in Glaser 1924, pp. 35ff. See also F. Fischer 1972 (I), pp. 26ff.

34. Göpel 1976, no. 414; Cologne 1984, no. 30. See also F. Fischer 1972 (I), pp. 133ff; and (II), pp. 57f.

35. F. Fischer 1972 (I), p. 134f.

36. Both in Berlin, Göpel 1976, nos. 478, 497; Munich/St. Louis 1984, nos. 81–82.

37. See chapter 4, note 29.

38. Göpel 1976, no. 470, and Munich/St. Louis 1984, no. 78. See also F. Fischer 1972 (I), pp. 132ff; and Zenser 1984, no. 36.

39. Göpel 1976, no. 439; Munich/St. Louis 1984, no. 73; P. Beckmann 1977, passim; and Dube 1981, passim.

40. F. Fischer 1972 (I), p. 133.

41. Beckmann 1979, p. 58.

42. This first appeared in *Die Literatur*, 37 [1935]. See Benn 1961, pp. 251ff.

43. Göpel 1976, no. 727; Munich/St. Louis 1984, no. 111; F. Fischer 1972 (II), pp. 75ff.

44. Diary entry for August 6–7, 1946, while Beckmann was working on the painting.

45. Göpel 1976, no. 770; Cologne 1984, no. 72. I am grateful to Peter Beckmann for the explanation of the board.

46. Göpel 1976, no. 809; F. Fischer 1972 (II), pp. 86f; Erpel 1981, no. 27. For the diary entry see Beckmann 1979, p. 367.

47. Johann Wolfgang Goethe, *Faust*, part 2, with 143 pen-and-ink drawings by Beckmann (Leipzig, 1982), p. 85. On the Faust drawings, see E. Beutler in Beckmann 1962, pp. 155ff, and Lenz, 1982, pp. 115ff. See also F. Fischer, in *Faust*, part 2, with pen-and-ink drawings by Beckmann (pub. Clusel Verlag, 1975), particularly pp. 477ff.

48. Göpel 1976, no. 821, and Munich/St. Louis 1984, no. 130.

49. Göpel 1976, no. 832, and Frankfurt 1981, no. 9.

50. Letter from Benn to F. W. Oelze dated June 16, 1956.

51. "Das Unaufhörliche" (1931). On the poetry of Gottfried Benn, see B. Hillebrand in Benn, *Gedichte in der Fassung der Erstdrucke* (1982), pp. 639ff.

52. "Untergrundbahn" (1913).

53. "Primäre Tage" (1930).

54. "Widmung" (1934).

55. In the essay "Goethe und die Naturwissenschaften."

BIBLIOGRAPHY

Beckmann 1909: *Leben in Berlin: Tagebuch 1908–1909*.
Munich, 1983. (Note: This is not the identification in
Munich/St. Louis 1984.)

Beckmann 1916: *Briefe im Kriege*, ed. Minna Tube. Berlin,
1916; 2nd ed., Munich, 1955.

Beckmann 1962: *Blick auf Beckmann: Dokumente und
Vorträge*, ed. Hans Martin Freiherr von Erffa and Erhard
Göpel. Munich, 1962.

Beckmann 1965: Beckmann, Peter, ed., *Max Beckmann,
Sichtbares und Unsichtbares*. Stuttgart, 1965.

Beckmann 1979: *Tagebücher 1940–1950* (2nd ed.), ed.
Erhard Göpel and Friedhelm Wilhelm Fischer.
Munich, 1979.

M. Q. Beckmann 1983: Beckmann, Mathilde Q., *Mein
Leben mit Max Beckmann*. Munich, 1983.

P. Beckmann 1977: Beckmann, Peter, *Die Versuchung: Eine
Interpretation des Triptychons von Max Beckmann*.
Heroldsberg, 1977.

P. Beckmann 1982: Beckmann, Peter, *Max Beckmann,
Leben und Werk*. Stuttgart, 1982.

Benn 1958: Benn, Gottfried, *Gesammelte Werke in vier
Bänden*, ed. D. Wellershoff, vol. 1. Wiesbaden, 1958.

Benn 1961: Benn, Gottfried, *Gesammelte Werke in vier
Bänden*, ed. D. Wellershoff, vol. 4. Wiesbaden, 1961.

Berlin 1983: *Max Beckmann: Die Hölle, 1919*. Exhibition
catalogue, Kupferstichkabinett, Berlin, 1983.

Bielefeld 1977: *Max Beckmann: Aquarelle und Zeichnungen
1903–1950*. Exhibition catalogue, Kunsthalle, Bielefeld
(also Tübingen and Frankfurt), 1977.

Blumenberg 1981: Blumenberg, H., *Arbeit am Mythos*.
Frankfurt, 1981.

Buenger 1979: Buenger, Barbara C., *Max Beckmann's
Artistic Sources: The Artist's Relation to Older and Modern
Traditions*. Ph.D. dissertation, Columbia University,
1979; University Microfilms, 1981.

Buenger 1984: Buenger, Barbara C., "Max Beckmann's
Amazonenschlacht: Tackling 'die grosse Idee,'" *Pantheon*,
42, 2 (1984), pp. 140ff.

Busch 1960: Busch, Günter, *Max Beckmann: Eine
Einführung*. Munich, 1960.

Cologne 1984: *Max Beckmann*. Exhibition catalogue, Josef
Haubrich Kunsthalle, Cologne, 1984.

Dube 1981: Dube, Wolf-Dieter, *Max Beckmann: Das
Triptychon "Versuchung."* Munich, 1981.

Dube 1982: Dube, Wolf-Dieter, "Auferstehung im Werke
Max Beckmanns," *Kunst und Kirche*, 45 (1982), pp. 65ff.

Einstein 1931: Einstein, Carl, *Die Kunst des 20.
Jahrhunderts* (3rd ed.), 1931, pp. 181ff.

Einstein 1970: Einstein, Carl, *Existenz und Ästhetik*, ed.
S. Penkert. Wiesbaden, 1970.

Erpel 1981: Erpel, Fritz, *Max Beckmann*. East Berlin,
1981.

F. Fischer 1972 (I): Fischer, Friedhelm Wilhelm, *Max
Beckmann: Symbol und Weltbild*. Munich, 1972.

F. Fischer 1972 (II): Fischer, Friedhelm Wilhelm, *Der
Maler Max Beckmann*. Cologne, 1972.

O. Fischer 1930: Fischer, O., "Die neueren Werke Max
Beckmanns," *Museum der Gegenwart*, 1 (1930), pp. 89ff.

Frankfurt 1981: *Max Beckmann: Die Triptychen*. Exhibition
catalogue, Städtische Galerie, Frankfurt, 1981.

Frankfurt 1982: *Max Beckmann: Die fruhen Bilder*.
Exhibition catalogue, Städtische Galerie, Frankfurt,
1982.

Frankfurt 1983: *Max Beckmann: Frankfurt 1915–1933*.
Exhibition catalogue, Städtische Galerie, Frankfurt,
1983.

Gandelman 1978: Gandelman, Claude, "Max Beckmann's
Triptychs and the Simultaneous Stage," *Art History*,
1, 4 (1978), pp. 472ff.

Glaser 1924: Glaser, Curt, Julius Meier-Gräfe, Wilhelm
Fraenger, and Wilhelm Hausenstein, *Max Beckmann*.
Munich, 1924.

Göpel 1955: Göpel, Erhard, *Max Beckmann und seinen
späteren Jahren*. Munich, 1955.

Göpel 1976: Göpel, Erhard and Barbara, *Max Beckmann:
Katalog der Gemälde* (2 vols.). Bern, 1976.

Gosebruch 1984: Grosebruch, Martin, *Mythos ohne
Götterwelt*. Esslingen, 1984.

Green 1976: Green, C., *Léger and the Avant-Garde*.
New Haven, 1976.

Güse 1977: Güse, Ernst-Gerhard, *Das Frühwerk Max Beckmanns* (Kunstwissenschaftlichen Studien, vol. 6). Frankfurt, 1977.

Hamburg 1979: *Der Zeichner und Grafiker Max Beckmann*, Exhibition catalogue, Kunstverein, Hamburg, 1979.

Hannover 1983: *Max Beckmann: Werke aus der Sammlung des Kunstmuseums Hannover mit Sammlung Sprengel.* Exhibition catalogue, Kunstmuseum, Hannover, 1983.

Hausenstein 1928: Hausenstein, Wilhelm, *Einleitung zur Ausstellung im Graphischen Kabinett München.* Munich, 1928.

Hausenstein 1929: Hausenstein, Wilhelm, "Max Beckmann," *Die Kunst*, 59 (1929), pp. 157ff.

Kaiser 1913: Kaiser, Hans, *Max Beckmann.* Berlin, 1913.

Karlsruhe 1963: *Max Beckmann: Das Porträt.* Exhibition catalogue, Badischer Kunstverein, Karlsruhe, 1963.

Kesting 1970: Kesting, M., *Entdeckung und Destruktion: Zur Struktur-Umwandlung der Künste.* Munich, 1970.

Lackner 1965: Lackner, Stephan, *Max Beckmann: Die neun Triptychen.* Berlin, 1965.

Lackner 1967: Lackner, Stephan, *Ich erinnere mich gut an Max Beckmann.* Mainz, 1967.

Lackner, 1983: Lackner, Stephan, *Max Beckmann.* Munich 1983.

Leipzig 1984: *Max Beckmann: Graphik, Malerei, Zeichnung.* Exhibition catalogue, Leipzig, 1984.

Lenz 1972: Lenz, Christian, "'Mann und Frau' im Werke von Max Beckmann," *Städel-Jahrbuch*, new ser. 3 (1971), pp. 213ff.

Lenz 1976: Lenz, Christian, *Max Beckmann und Italien.* Frankfurt, 1976.

Lenz 1982: Lenz, Christian, "Die Zeichnungen Max Beckmanns zu 'Faust,'" *Goethe in der Kunst des 20. Jahrhunderts*, pp. 82ff. Exhibition catalogue of the Goethe Museum, Frankfurt, 1982.

Mannheim 1925: *"Neue Sachlichkeit": Deutsche Malerei seit dem Expressionismus.* Exhibition catalogue, Städtische Kunsthalle, Mannheim, 1925.

Mannheim 1981: *Max Beckmann: Pierrette und Clown, 1925.* Exhibition catalogue, Städtische Kunsthalle, Mannheim, 1981.

Meier-Gräfe 1919: Meier-Gräfe, Julius, *Einleitung zu Beckmanns Mappe "Die Gesichter."* 1919. Reprinted in Beckmann 1962.

Meier-Gräfe 1924: Meier-Gräfe, Julius, *Entwicklungs-geschichte der modernen Kunst*, vol. 3., in particular pp. 675, 676ff, and the introduction. Munich, 1924.

Meier-Gräfe 1929: Meier-Gräfe, Julius, "Max Beckmann: Zu einer Ausstellung in der Galerie Flechtheim," *Berliner Tageblatt*, January 15, 1929.

Munich/St. Louis 1984: *Max Beckmann: Retrospective*, ed. Carla Schulz-Hoffmann and Judith C. Weiss. Munich and St. Louis, 1984. Catalogue for the exhibition that originated at the Haus der Kunst, Munich, and traveled to the Nationalgalerie in Berlin, The Saint Louis Art Museum, and the Los Angeles County Museum of Art. The catalogue was published in German and English.

Otto 1928: Otto, W. F., *Die Götter Griechenlands: Der Spiegel des Göttlichen im Spiegel des griechischen Geistes.* Frankfurt, 1928.

Otto 1933: Otto, W. F., *Dionysos: Mythos und Kultus.* Frankfurt, 1933.

Piper 1950: Piper, Reinhard, *Nachmittag: Erinnerungen eines Verlegers.* Munich, 1950, pp. 11ff.

Reifenberg 1949: Reifenberg, Benno, and Wilhelm Hausenstein, *Max Beckmann.* Munich, 1949.

Reifenberg 1970: *In Memoriam Benno Reifenberg* (Max Beckmann Gesellschaft). 1970.

Roh 1925: Roh, Franz, *Nach-Expressionismus. Magischer Realismus: Probleme der neuesten europäischen Malerei.* Leipzig, 1925.

Schubert 1978: Schubert, Dietrich, review of Güse 1977, in *Zeitschrift für Kunstgeschichte*, 1978, pp. 342ff.

Schubert 1982: Schubert, Dietrich, "Nietzsche-Konkretis. formen in der bildenden Kunst 1890–1933," *Nietzsche-Studien*, 10–11 (1981–1982), pp. 278ff.

Schubert 1983: Schubert, Dietrich, "Die Beckmann-Marc-Kontroverse von 1912," in B. Hüppauf, ed., *Expressionismus und Kulturkrise*, pp. 207ff. Heidelberg, 1983.

Selz 1964: Selz, Peter, *Max Beckmann.* New York, 1964.

Simon 1930: Simon, H., *Max Beckmann* (*Junge Kunst*, vol. 56), Berlin/Leipzig, 1930.

Westheim 1923: Westheim, Paul, *Für und wider: Kritische Anmerkungen zur Kunst der Gegenwart.* Potsdam, 1923.

Wichert 1931: Wichert, F., "Max Beckmann," *Kunst und Künstler*, 29 (1931), pp. 7ff.

Wiese 1978: Wiese, Stephan von, *Max Beckmanns zeichnerisches Werk 1903–1925.* Düsseldorf, 1978.

Zenser 1984: Zenser, Hildegard, *Max Beckmann: Selbstbildnisse.* Munich, 1984.